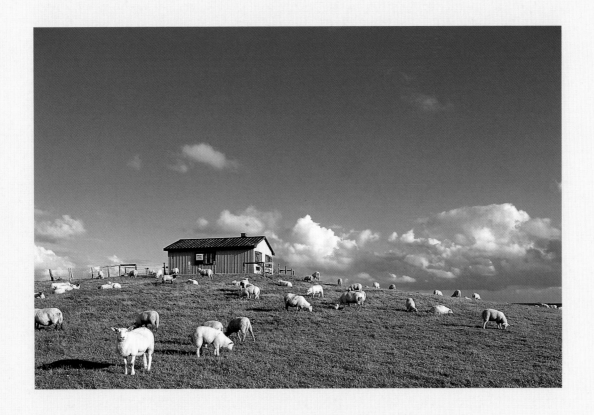

Journey through

# SCHLESWIG-
# HOLSTEIN

Photos by
Karl-Heinz Raach and
Johann Scheibner

Text by
Georg Schwikart

Stürtz

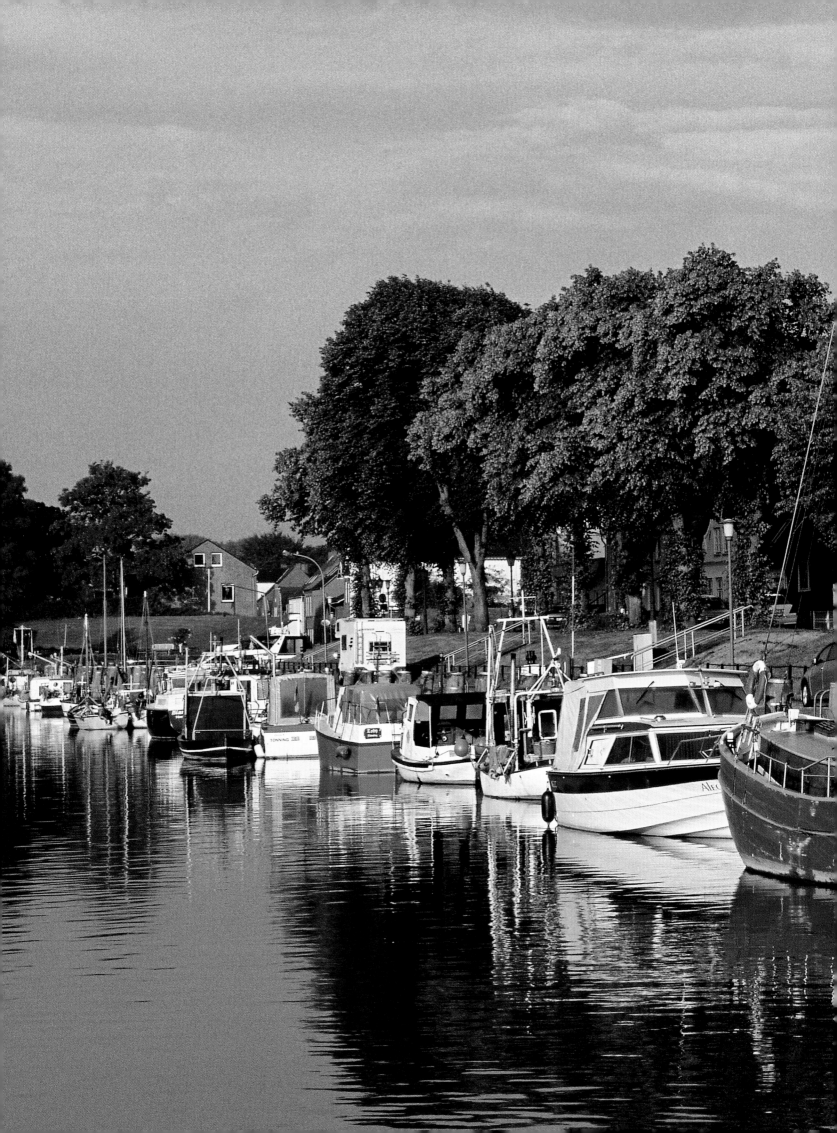

**First page:**
The isle of Hamburger Hallig in the North Frisian Wadden Sea, linked to the mainland by a dyke since 1860, is now a nature conservation area boasting a diverse bird life.

**Previous page:**
Near where the Eider flows into the North Sea is the little town of Tönning with its historic harbour and striking buildings from the 17th and 18th centuries.

**Below:**
For centuries the Oldenburger Wall was a strategic Slav settlement. The time around 1100 is brought back to life each summer during the Slawentage festival, where ancient costumes, crafts and music can be admired.

**Page 10/11:**
In the Schleswig-Holstein Wadden Sea National Park lies the island of Pellworm, surrounded by a dyke eight metres (26 feet) wide and 28 kilometres (17 miles) long. Dykes are essential here: as the saying goes, either build one – or yield to the terrific force of the raging sea.

# Contents

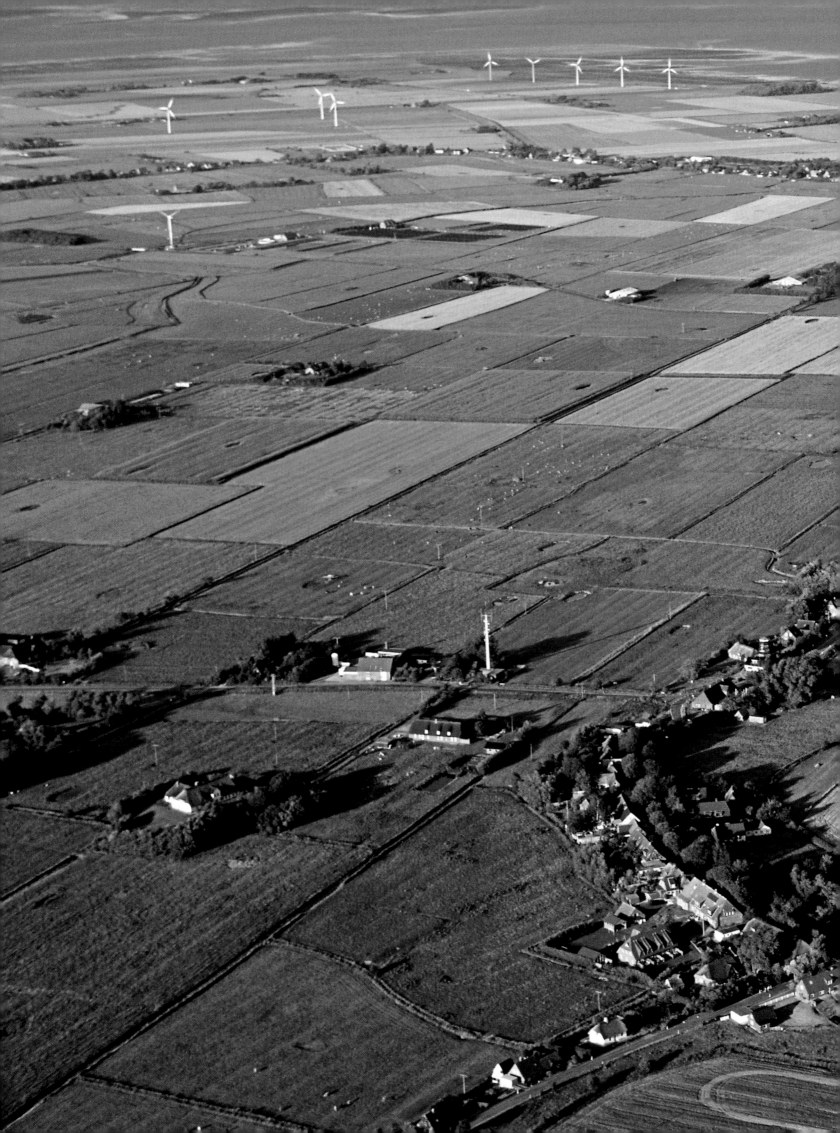

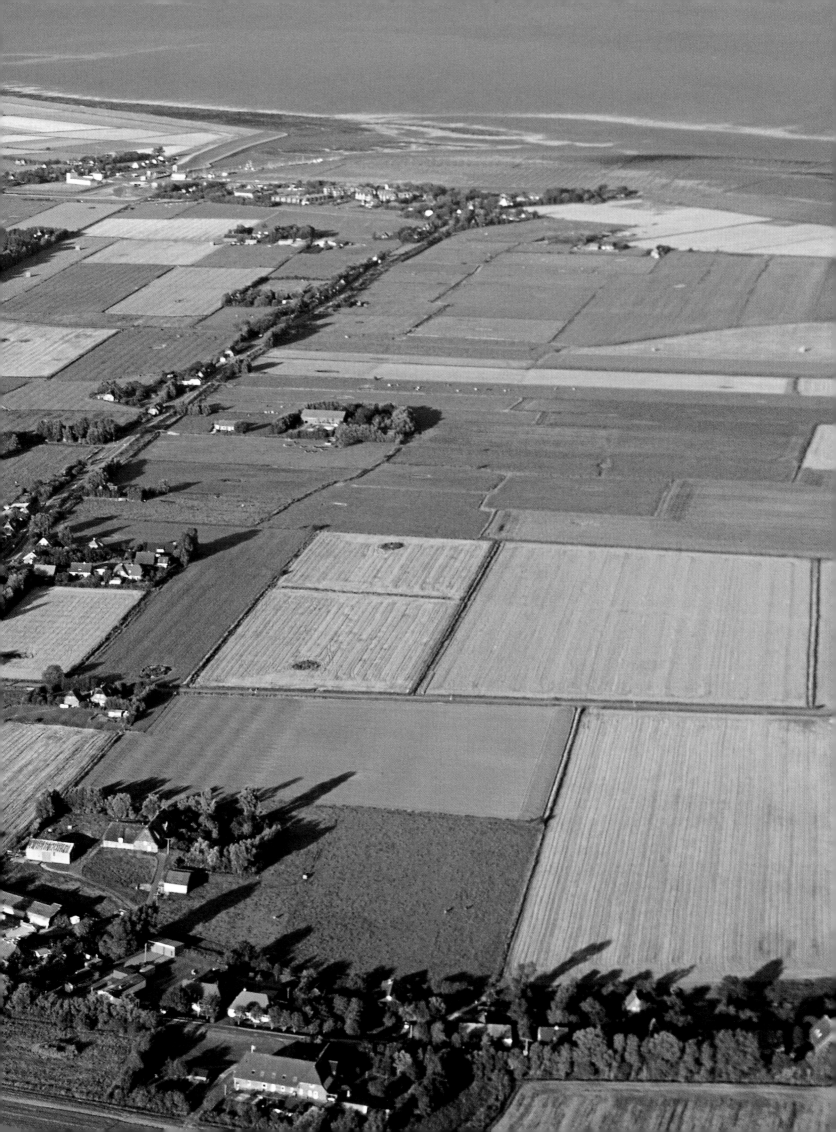

# Surrounded by the sea: Schleswig-Holstein

*Typical Frisian house in the village of Nebel on the island of Amrum. Nearly all of the houses in the historic village centre are thatched with reed.*

The sea, the mudflats and wind which tastes of salt; thatched roofs, lighthouses and wind power stations; screaming seagulls and bleating sheep; salt marsh, coastal moorland and sand dunes: a multitude of visions, sounds and smells both natural and cultural make up the fascinating mosaic of the second-smallest federal state in Germany, of Schleswig-Holstein, the land surrounded by the North and Baltic seas. It lies tucked in between the two shorelines left and right, between the international border of Denmark in the north and the regional boundaries of Hamburg, Lower Saxony and Mecklenburg-Pomerania in the south. The River Eider and the Kiel Canal or Nord-Ostsee-Kanal, opened in 1895, draw a more or less perfect line between the former miniature states of Schleswig in the north and Holstein in the south. The northernmost federal state of Germany has a surface area of about 16,000 square kilometres (ca. 6,200 square miles) and forms the southerly end of the Jutland Peninsula. Its geography and natural habitat were largely determined during the big melt of the last glacial period around 18,000 years ago. To the west of the state are the islands of North Frisia and the Hallig Isles dotted about the Wattenmeer or Watt (English: Wadden Sea or "wading sea"), 15 to 30 kilometres (nine to 18 miles) wide. The west coast with the Eiderstedt Peninsula and the Bay of Husum has a relatively spartan structure.

### Of marsh and moor

Inland of the Watt and the salt flats lies the marsh, a level, very wet floodplain fed by the rivers and the sea. It was formed after the last ice age and is practically at sea level. Marshes protected by dykes are called *Koog*; these are what the Dutch refer to as polders. There are about 180 *Köge* on the west coast of Schleswig-Holstein, one of these being the Beltringharder Koog near the Bay of Nordstrand. East of the marsh is the less fertile soil of the geest, sandy, slightly hilly moorland about ten to 50 metres (30 to 160 feet) above sea level which was formed by deposits from older ice ages. The word is derived from the Lower German adjective *gest* for "dry" or "infertile".

The fertile moraine landscape in the east and southeast of the state, Schleswig-Holstein's Hügelland, is rich in forest and lakes, such as the Selenter, Plöner and Ratzeburger Seen. Its highest point, the 168 metres (551 feet) of the Bungsberg in the Holsteinische Schweiz or Holstein Switzerland, serves as its sole winter sports resort with its very own ski lift – operated only on the few days the hill is actually covered in snow.

Along the mostly steep Baltic Coast with its peninsulas of Angeln and Wagrie there are four narrow bays with access to the sea, known here as *Förde* or fjords, to use the Scandinavian word. Just off the coast is the island of Fehmarn.

189 designated nature reserves and 275 countryside conservation areas are aimed at helping preserve the beauty of this part of Germany. To these must be added the five nature parks in the hills of the Hüttener Berge, on the Westernsee, in Aukrug, in the Holsteiner Schweiz and near the lakes of Lauenburg. None of these border on the sea or the coast.

The countryside hemmed in by the two seas is not surprisingly moulded by them. The Baltic has weak tides; the North Sea, on the other hand, fuelled by the North Atlantic, is much stronger, with a tidal range of two to four metres (six to 13 feet). The interplay of high and low tide is constantly reworking the coastline. Low tides reveal the fascinating mudflats of the Watt where the smaller inhabitants of the sea can be closely observed: snails, crabs, worms, shells and starfish. The Schleswig-Holstein Wadden Sea National Park founded in 1985 was made a UNESCO Biosphere Reserve in 1990.

### Lethal flooding

As the tide rises, the great flood begins – in some cases with drastic results, when storm tides raise normal water levels by as much as a metre. The building of protective dykes has thus proved vital – in tune with the local saying that if you don't build, you'll have to yield ("Wer nicht deichen will, muss weichen"). Storm tides have been part and parcel of Schleswig-Holstein's history since the end of the last glacial period. In the First Flood of St Marcellus on January 16, 1219, the feast day of St Marcellus I, it's thought that about 36,000 perished. St Lucia's Flood on December 14, 1287, cost around 50,000 lives. January 15/16, 1362, saw the Second Flood of St Marcellus which went down in the annals of history as the Grote Mandrenke or Great Drowning of Men. Historic chronicles tell of 100,000 dead.

This devastating flood radically changed the line of the coast. Up to this point the shore of what is now the Watt of North Frisia had been

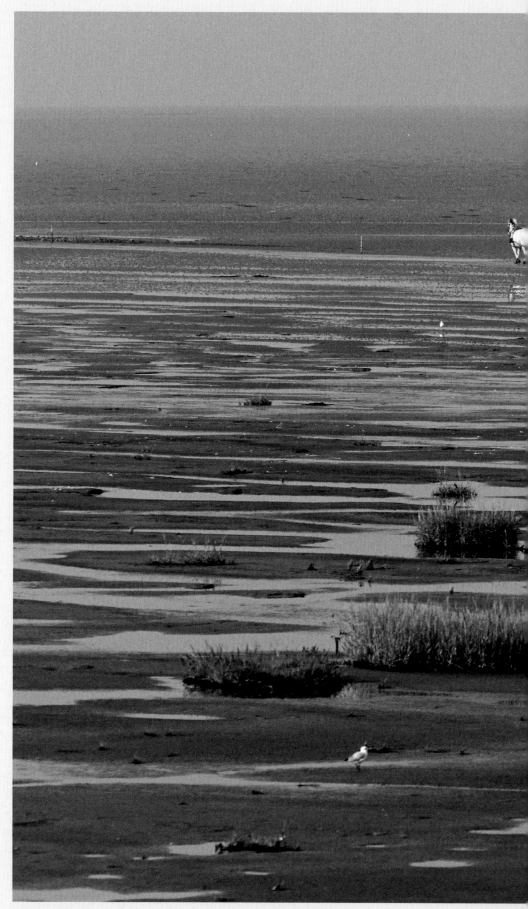

*From Fuhlehörn on Nord-
strand summer visitors can
travel to Hallig Südfall on a
horse and cart. The sedate
journey takes you through
flat, narrow channels and
past mussel beds in the
Wadden Sea.*

a single line running from Eiderstedt to Sylt, interrupted only by Prielen. The storm tide crashed 2.4 metres (8 feet) over the dykes, flooding the marsh up to the edge of the geest in places. The sea cut a large section of land off from the mainland, creating the marsh island of Strand. It also formed the Hallig Isles. Towns such as Niedam and Rungholt sank without trace. Legends arose; for centuries Rungholt was a rich city which had been punished for its haughtiness, like Vineta on the Baltic, and doubts were expressed as to whether it had ever existed at all – until between 1921 and 1938 the sea washed up remains of weapons, buildings and wells at the alleged site.

Further storm tides followed. The October of 1634 was tragically marked by the Burchardi Flood, also called the Second Grote Mandrenke. In North Frisia alone an estimated 9,000 people fell victim. Pellworm, Nordstrand and the Hallig Isle of Nordstrandischmoor were all that was left of Strand. The Halligs of Nieland and Nübbel completely disappeared. Over 1,300 houses, 28 windmills and 50,000 animals went down with the islands.

The spring tide of February 3/4, 1825, turned out to be the flood of the 19th century. Up until 1962 it was the highest storm tide on the Elbe and has remained imprinted on memories as the Hallig Flood. The Hallig Isles were where the greatest damage was done; the sea swallowed up all of the islands save the few remaining today. In Jutland the North Sea broke down all land barriers to Limfjord.

Thanks to the massive efforts made to protect the coast in the 1950s Schleswig-Holstein got off relatively lightly during the heavy North Sea or Hamburg flood of February 16/17, 1962. 340 people died, 315 of them in Hamburg. 20,000 were made homeless. 25,000 helpers were deployed under the leadership of Hamburg's then minister for internal affairs and later German chancellor (1974 to 1982) Helmut Schmidt. The tide only receded after four weeks. Man's battle with the angry sea, known

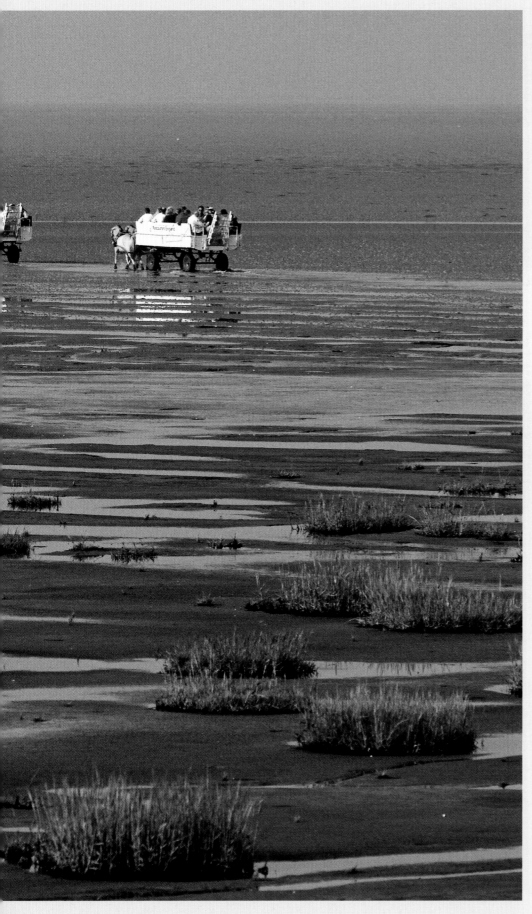

in the north as *Blanker Hans*, is documented at Husum's museum-cum-theme park called the Blanker Hans Sturmflutenwelt.

### Wild tribes north of the Elbe

The first people who lived in what is now Schleswig-Holstein were hunter-gatherers. They settled in the area as farmers and livestock breeders 6,000 years ago. Between 3500 and 2800 BC they erected stone circles and buried their dead in barrows or tumuli. In c. 100 AD the Roman historian Tacitus (c. 58–116) mentioned "wild tribes" north of the Elbe: Cimbri, Ambrones and Teutons. In the early Middle Ages there were four ethnic groups living in today's Schleswig-Holstein: Danes and Jutes in the north, Frisians in the west and on the islands, Saxons in the south and Slavs in the east.

West of what is now Schleswig, from the 8th to 12th centuries the Danish kings built a defensive earthwork called the Danevirke, designed to fend off enemies from the south. Confrontations between the Christian Franks and the heathen Teutons of the north eventually resulted in the signing of a peace treaty in 811 by the Carolingians and the Danes, in which the River Eider was recognised as an official boundary. With peace restored the Viking town of Haithabu or Hedeby ("heath yard", now Haddeby near Schleswig) evolved on the western shores of the Schleibucht. The merchant city soon thrived, becoming a humming centre of trade for the countries on the North and Baltic seas, for Scandinavia and the German Frankish empire. Some contacts even went as far as Arabia and China. In 1066 Haithabu was destroyed by the West Slavs. The days of Harald Blauzahn ("blue tooth") and Sven Gabelbart ("forked beard") are now commemorated by the city of Schleswig at their spectacular Viking Festival (the Wikingertage) which attracts thousands of visitors.

### Queen of the Hanseatic League

The land between the two seas was highly contended and often changed hands. Swedes and Norwegians surged in from the north, with Saxons swarming the country from the east and Germans from the south. In the 13th and 14th centuries the Hansas gained a steady footing. Initially a league of cities focussed entirely on trade, the conglomeration soon rose to political power. The capital and Queen of the Hanseatic League was Lübeck. Henry the Lion, who also founded Munich, had the harbour extended in 1158, lending the city great strategic importance. By 1370 the Hansas were so influential that their consent was required in the choice of the next king of Denmark.

The year 1460 looms particularly large in the history of Schleswig-Holstein. In the Treaty of Ribe the nobles of both countries elected Danish King Christian I both duke of Schleswig and count of Holstein. Henceforth Schleswig and Holstein were to "bliven ewich tosamende ungedeelt" – or to remain forever undivided. Christian's sons appear not to have read the small print and subsequently split the country up amongst themselves. The duchies of Schleswig and Holstein were divided up into diverse domains on more than one occasion. In 1773, however, they again found themselves under the (almost) exclusive rule of Denmark. In the throes of 19th-century Nationalism, in 1848 the tussle again began for the duchy of Schleswig between the Danes in the north of the region and the Germans in the south.

In the wake of the 1866 Prussian-Austrian War, in 1867 the duchies of Schleswig and Holstein fell to Prussia. The man who orchestrated the move, which did little to satisfy the independently-minded inhabitants, was Imperial Chancellor Otto von Bismarck. It wasn't until 1920 – and after a certain amount of pressure had been applied by the victorious powers in the northern part of Schleswig – that the plebiscite agreed on in 1866 was held, in which several constituencies opted for rule by Denmark.

The conflict finally came to an end in 1955 with the Bonn-Copenhagen Declarations, in which both states guaranteed protection and equality for their minorities. 50,000 Danes are now resident in South Schleswig; they even have their own minority party, the Südschleswigscher Wählerverband (SSV or South Schleswig Electoral Association), which is exempt from Germany's 5 percent electoral clause. Another minority group is formed by the ca. 8,000 speakers of Frisian. There are several dialects which are so different that locals can often hardly understand one another. In the district of North Frisia and on the island of Helgoland Frisian is the official lingo, with some of the road signs even printed in two languages.

The federal state of Schleswig-Holstein now numbers 2.8 million. The density of the population adds up to 179 people per square kilometre yet the distribution is very diverse. Besides the two major cities of Kiel and Lübeck and a few large and small towns, compared to the rest of Germany there is an inordinate number of villages with less than 500 inhabitants. With just 301 people to its name (last count: December 31, 2007) Arnis is the smallest town in Germany and Wiedenborstel (also last logged at the end of 2007) the smallest autonomous community – with just five residents.

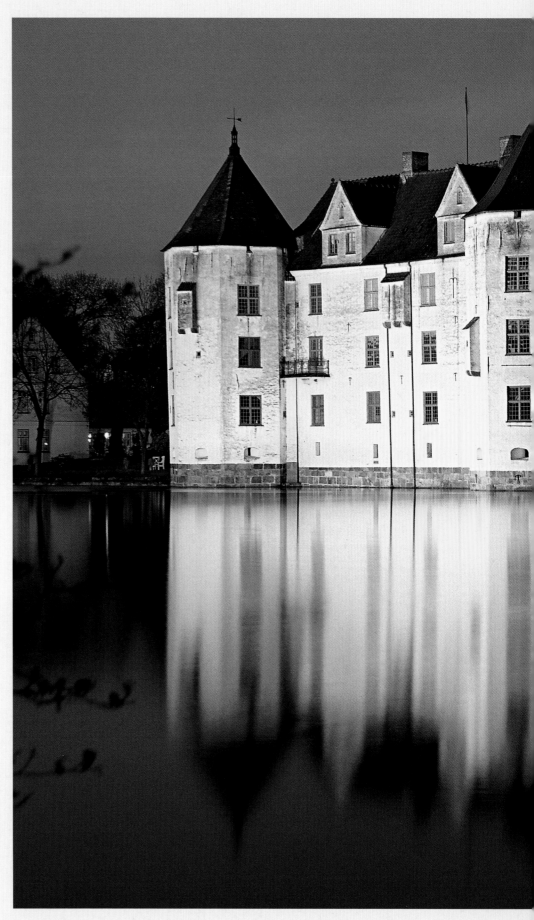

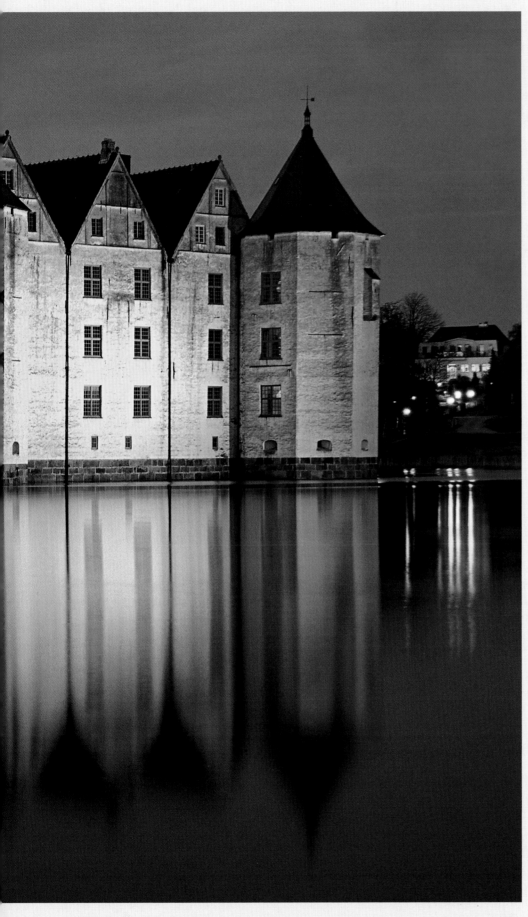

One of the most beautiful
Renaissance palaces in
northern Europe is Schloss
Glücksburg on the fjords
of Flensburg, dating back
to the 16th century. It now
houses a museum.

### Apostle of the north

Schleswig-Holstein is a largely Protestant state. In 830 archbishop of Hamburg Ansgar (801–865) set off as the "apostle of the north" to try and convert the 'heathens' to Christianity. The northerners obviously took some convincing; Christianity wasn't generally practised here until the 12th century. Churches have since survived from all centuries and epochs, many of them worth visiting.

Where there was a distinct lack of natural stone for building, bricks were used, particularly in the North German flatlands. Brick architecture is typical of the region. Statues and figures were impossible to make in brick, which explains why the exteriors of these edifices often seem rather plain. Instead, elaborate facades were designed using brick patterns and ornaments, glazed and unglazed tiles and sections of white plastering to great effect. The absolute highlights of North German brick architecture are the cathedrals of Ratzeburg, Schleswig and Lübeck, the latter having had its foundations laid in 1173 by none other than Henry the Lion.

The Protestants in Hamburg and Schleswig-Holstein are now part of the North Elbe Evangelical-Lutheran Church based in Kiel. About 56 percent of the inhabitants of Schleswig-Holstein are practising Protestants and just six percent Catholic. There are also other Christian groups, Muslims and Jews. Around one third do not belong to a religious community.

Economically speaking, with just two big cities Schleswig-Holstein is structurally rather weak; half of the gross national product comes from the service industry. The state is plagued by a debt of about 22 billion euros. The largest single employer in the region is the Bundeswehr or the German navy yet here, too, cuts are in the pipeline. Schleswig-Holstein also boasts the biggest shipyard in Germany: the Howaldtswerke-Deutsche Werft GmbH in Kiel.

Around half of the fish caught by cutter and coastal fishing in Germany comes in through harbours in Schleswig-Holstein. Agriculture is

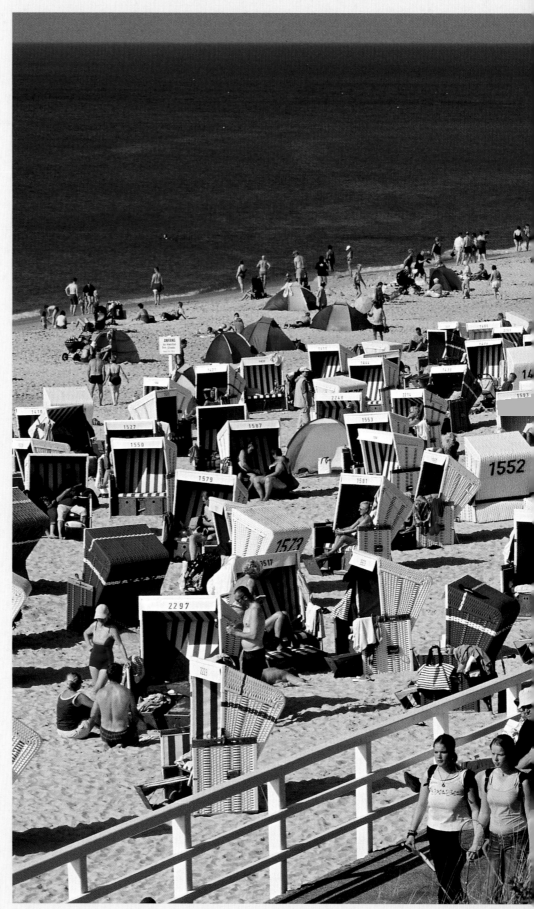

geared towards meat and dairy livestock breeding; with an average of 57 cows per farm the state is about 20 animals up on the rest of the country. Wheat and sugar beet is grown in the southeast and the Halstenbek area northwest of Hamburg has the biggest array of tree nurseries in the world. Fruit and vegetables are farmed in the west.

One definite area of growth is wind power on the west coast. The 2,500 windmills in Germany's northernmost state generate about 36 percent of the electricity used here. Kaiser-Wilhelm-Koog, one of the windiest areas of Germany in south Dithmarschen, is where it all began; in 1983 what was then the biggest wind power station in the world was set up, with Germany's first wind park opened in 1987.

### Authors and artists

Schleswig-Holstein is a land rich in literary tradition, this demonstrated by names such as Theodor Storm, Klaus Groth, the brothers Heinrich and Thomas Mann and James Krüss. Its more illustrious artists include Emil Nolde (1867–1956), one of the leading Expressionist painters and also a great 20th-century watercolourist. His real name was Hans Emil Hansen; he changed his name to that of his native North Schleswig Nolde in 1902.

Between 1927 and 1937 Nolde's new house and studio were built according to his plans in Seebüll on the German side of the border. Although he was a member of the Nazi party, the National Socialists decreed that his art was "degenerate". Over a thousand of his pictures were confiscated, some of them sold and some destroyed. In 1941 he was forbidden to paint. He retreated to Seebüll where he executed over 1,300 small-format watercolours which he later referred to as his "unpainted pictures". The Nolde Museum in Seebüll stages exhibitions of his oeuvre centred around various topics. Nolde's life and times during his "painting ban" from 1941 onwards are captured in the novel *Deutschstunde* (German Lesson) by Siegfried Lenz, published in 1968.

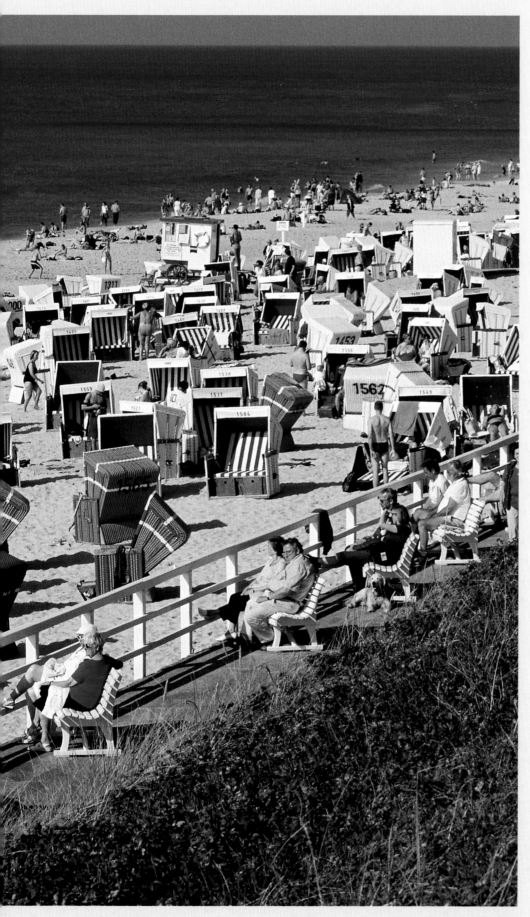

Sculptor, writer and artist Ernst Barlach (1870–1938) was born in Wedel in Holstein. He was active in his native north for only a brief period before moving to Güstrow in Mecklenburg in 1910. He made sensitive, expressive memorials and was also prolific in the field of literature. Two museums celebrate his work in Schleswig-Holstein, one at his place of birth in Wedel and one in Ratzeburg where he is buried. The most extensive collection of Barlach's work is held at the Ernst-Barlach-Haus in Hamburg.

### Buxtehude, Bach and Brahms

One of the best-known composers of the north is Dieterich Buxtehude (c. 1637–1707) who was appointed organist to St Mary's of Lübeck in 1668. Already famous in his own right, the Baroque composer of cantatas and organ music was joined in 1705 by the twenty-year-old Johann Sebastian Bach who was earmarked as Buxtehude's successor. Bach turned him down – because, it's said, one of the conditions was that he marry Buxtehude's daughter. Carl Maria von Weber (1786–1826), conductor, pianist and composer of the opera *Der Freischütz* (The Marksman), was born in Eutin but left the north with his family when he was still a baby. Weber never returned to his homeland, choosing to make his mark elsewhere. This hasn't stopped Schleswig-Holstein; a festival in Weber's honour has been held in his native Eutin every year since 1951. We also mustn't forget Johannes Brahms (1833–1897). He may have been born in Hamburg; his family, however, was originally from Heide. Brahms concerts, lectures and courses are staged at the Brahms-Haus in Heide, where an exhibition marks the major stages in the life of the great composer and outlines his friendship with the poet Klaus Groth.

Since 1986 these musical events have been joined by the outstanding international Schleswig-Holstein Musik Festival (SHMF), called into being by pianist Justus Frantz and the then leader of Schleswig-Holstein Uwe Barschel. Each July and August 130 concerts attended by an audience of over 100,000 are put on. Palaces and manor houses, barns and stables, the best churches in the land and also more unusual venues, such as airport terminals and old industrial plants form the backdrop for performances otherwise only proffered in concert halls and opera houses. Music festivals in the country make up the core of the SHMF, where concerts are played in atmospheric venues perfectly suitable for all the family. Visitors can combine classical music with picnic hampers on some of the loveliest estates in the country. A very different clientele is targeted on the first weekend

in August by the Metal Open Air Festival in Wacken – the ultimate venue for the heavy metal scene.

The Karl-May-Spiele in Bad Segeberg are a different kettle of fish altogether. Since its founding in 1952, this is where you come if you want to see the adventures of Karl May performed open air. Stars such as Pierre Brice and Gojko Mitić pull crowds in their thousands to the 7,500-seater Kalkbergstadion.

### Land of horizons

Schleswig-Holstein has ca. 180,000 beds for tourists. Around three million guests a year spend 15 million nights here. Approximately nine percent come from abroad, but most are German – and in view of the trend towards holidaying in your own country, this number could increase. The resorts on the Baltic Coast have slightly more visitors than those on the North Sea; North Sea visitors stay longer, however, resulting in more nights booked here than in the east. The ten most 'successful' tourist destinations are, in descending order of number of nights: Sankt Peter-Ording, Westerland, Grömitz, Timmendorfer Strand, Büsum, Wyk auf Föhr, Burg auf Fehmarn, Scharbeutz, Norddorf and Wenningstedt.

And what can we say about the people here? Any generalisations must, of course, be taken with a pinch of (sea) salt. Local journalist Manfred Wedemeyer once wrote of his fellow northerners "The Schleswig-Holsteiner stands with legs astride on his native soil, taciturn, barely manoeuvrable, not easily thrown and of a dry humour. Self-assured and self-satisfied, he is apt to poke fun at others, usually in good faith." These others might include the chatterboxes pouring into his country on holiday who seem to have so much to talk about ...

"Life is good in Schleswig-Holstein. Once you've settled in this land of horizons, you'll never want to leave the north", claims the confident blurb on the state's official website. The feeling in this little country between the seas is more eloquently expressed by singer-songwriter and jazz musician Knut Kiesewetter in

his 1972 song *Fresenhoff*. In it he sings "Wenn der Wind dreht, von Norden weht und Regen gegen die Fenster schlägt, die Scheiben herab läuft, dann fühle ich mich wohl." Roughly translated as "When the wind howls from the north and the rain beats the windows, dripping down the panes, I feel good", these are sentiments many a coastal resident – in Schleswig-Holstein, the Netherlands, the British Isles or anywhere else – can empathise with ...

*Page 22/23:*
*View out across the River Schlei of the cathedral in Schleswig with its west tower, 112 metres (367 feet) high. The Schlei is a saltwater arm of the Baltic running 42 kilometres (26 miles) from Schleswig to Schleimünde.*

*Page 24/25:*
*This avenue of limes cuts a straight line the Romans would have been proud of through blossoming fields of rape near Malente-Rachut in Ostholstein. The village rose to fame as the training camp of the national German football team.*

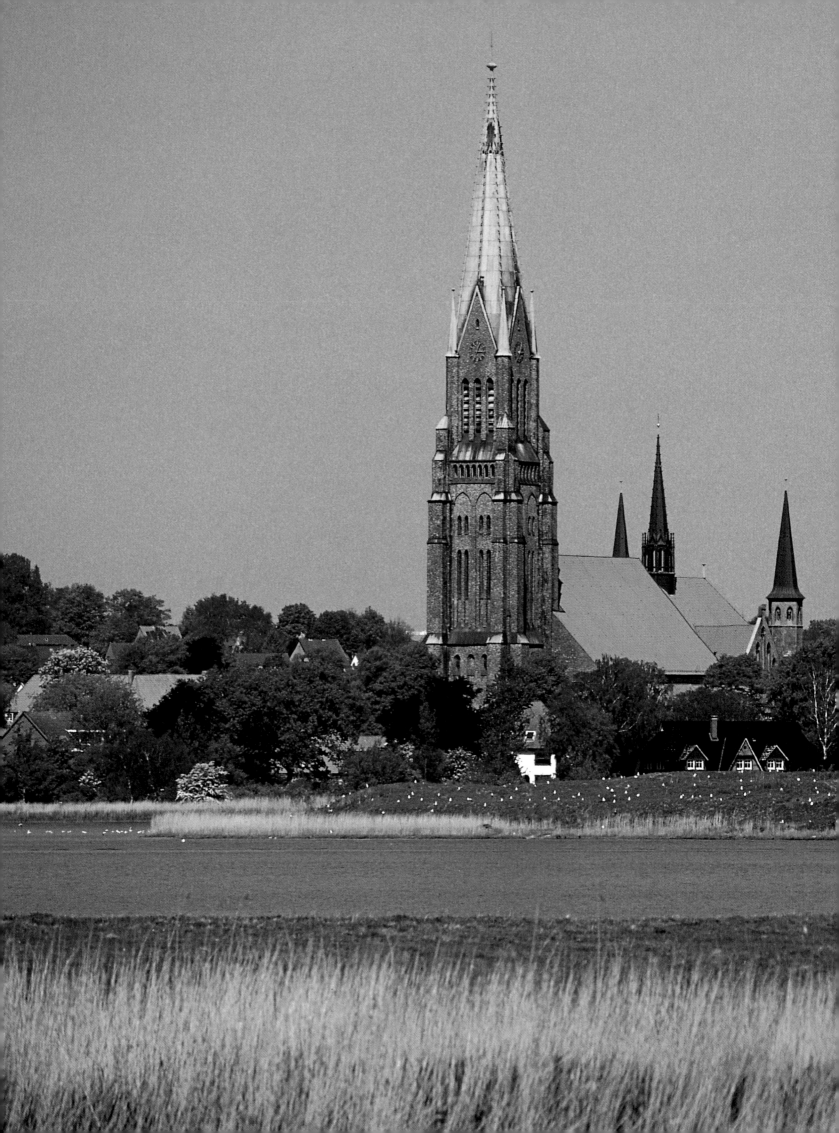

# From Glückstadt to North Frisia: the west

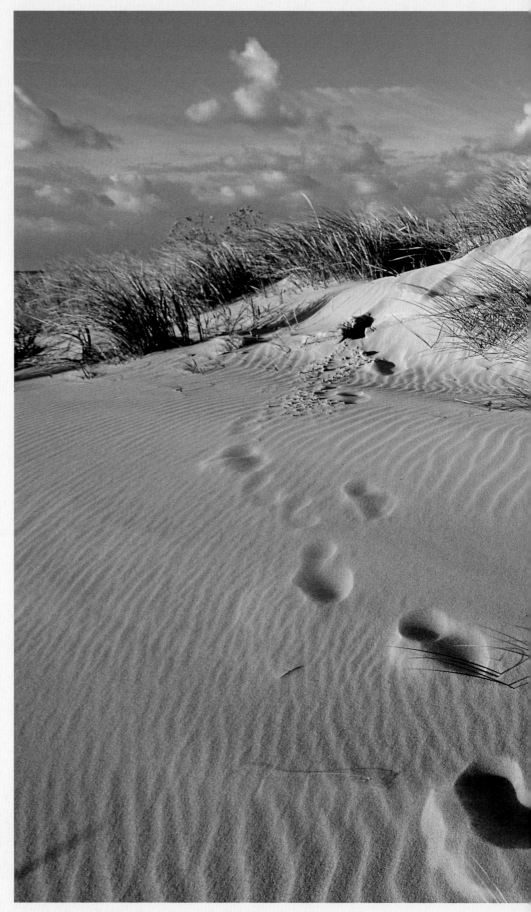

*In the dunes close to Sankt Peter-Ording. Going by the numbers of nights spent here, the officially recognised seaside resort and spa is the largest in Germany.*

En route for the tourist havens of Dithmarschen, Eiderstedt and North Frisia you should allow time for a few stops and detours. Glückstadt, for example, is well worth a visit. Founded in 1617 on the north bank of the Lower Elbe, this is definitely a town planned on the drawing board. Its smart, historic centre was designed as – and still is – an almost perfect hexagon. Northeast of Glückstadt is Itzehoe, one of the oldest towns in Schleswig-Holstein. As far back as 800 AD a ring fort was erected here under Emperor Charlemagne to try and undermine the threat of Danish Vikings advancing from the north. Büsum is right on the coast and was originally an island; constant land filling and dyke building finally linked it to the mainland in 1585. The Eiderstedt Peninsula was formed in the same way, with its three islands gradually becoming one from the 11th century onwards. Its local landmark is the Westerheversand Lighthouse.

There's also plenty to see inland, one such place being Heide with the largest undeveloped market square in Germany measuring 4.7 hectares (11 acres). Entering Friedrichstadt is like stepping into the Netherlands; the centre of trade was established by Dutch refugees in 1621 who turned the town into a veritable miniature Holland, complete with canals and gabled houses.

The cultural and economic hub of North Frisia is Husum with its harbour bay in the middle of town. Seebüll near the Danish border was where painter Emil Nolde lived and worked; the local museum attracts about 100,000 art aficionados a year. The North Frisians are said to be "rüm Hart, klaar Kiming", of a big heart with clear horizons; in other words, as you may well find for yourself, the people here are both generous and far-sighted.

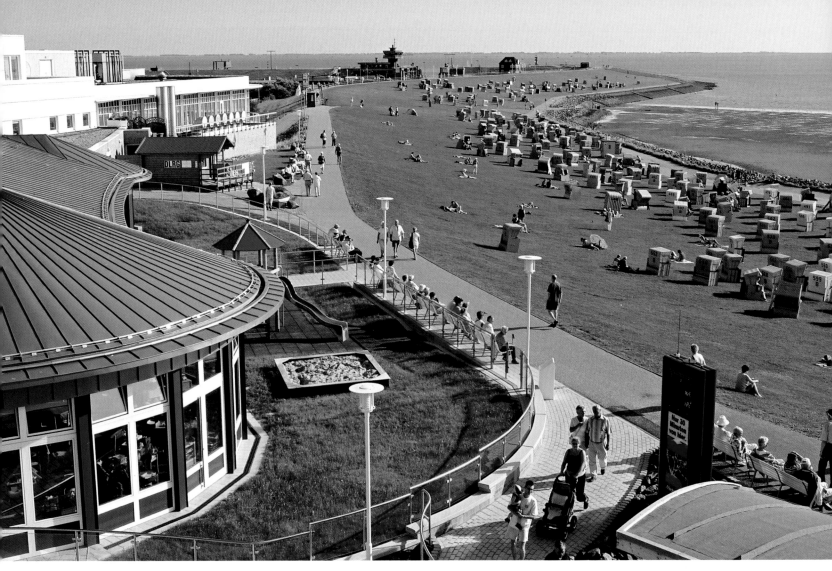

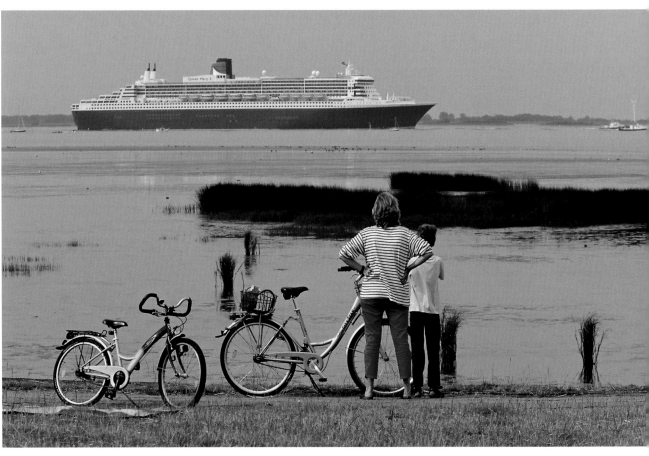

**Above:**
Bathing beach in Büsum,
the hub of the tourist trade
in the Dithmarschen area.
The seaside town became
popular at the end of the
19th century when trans-
port links were improved.
The railway line to Heide,
for example, was instated
in 1883; today trains run
every hour.

**Right:**
A veritable queen of the
sea on the River Elbe near
Glückstadt. Commissioned
in 2004, the Queen Mary 2
is one of the largest and
most expensive passenger
ships in the world.
345 metres (1,132 feet)
long, it's 76 metres
(249 feet) longer than the
Titanic.

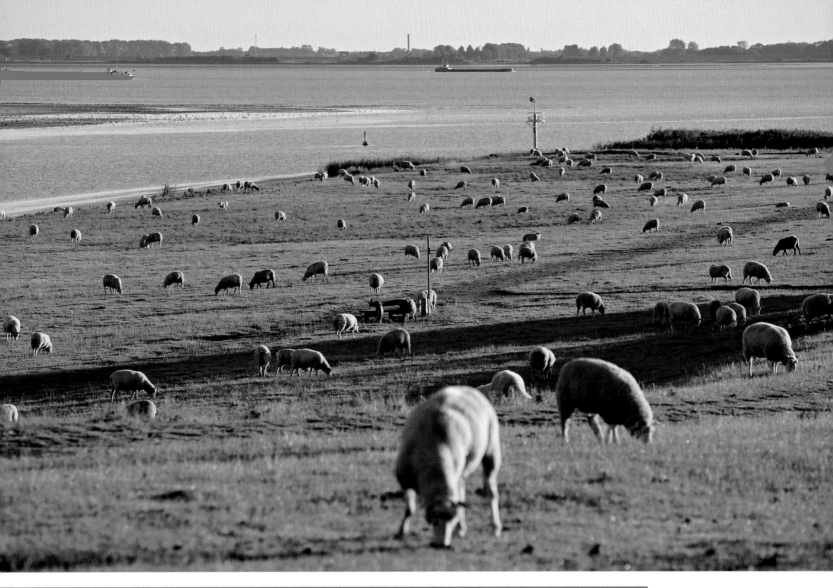

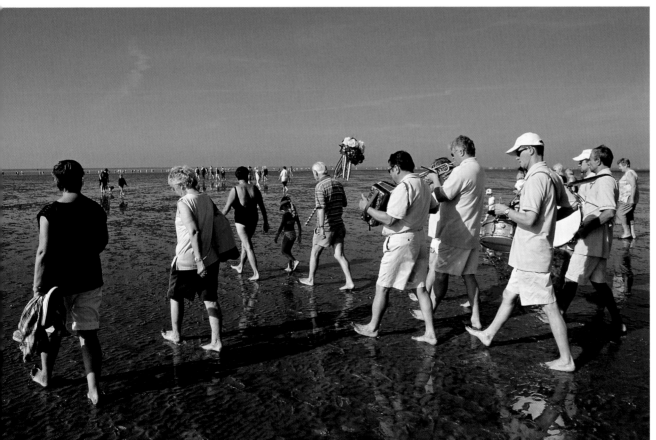

**Above:**
Whatever the weather, these sheep safely graze the meadows of the Elbe near Glückstadt, where the river is around three kilo-metres (nearly two miles) wide. The border between Schleswig-Holstein and Lower Saxony runs through the middle of it.

**Left:**
Wading through the mud-flats to the dulcet tones of the Büsum-Sextett – who have sensibly abandoned their footwear. Having a band play whilst you splash through the shallows is nothing new; in c. 1900 a visitor from Hamburg did just that. Today the local ensemble invites you to tap your (bare) feet in time to the music about sixty times a season.

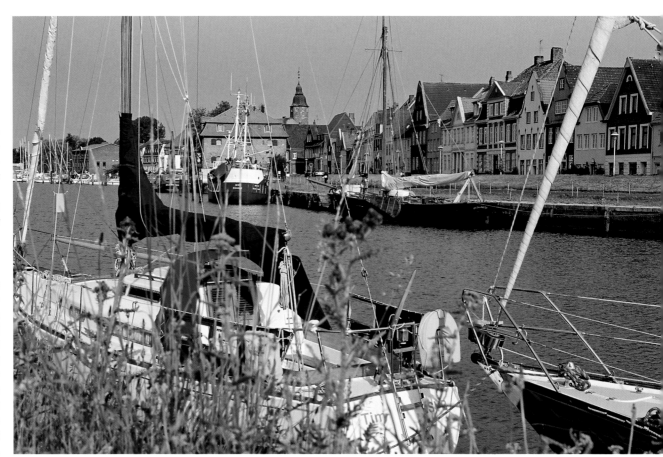

**Right:**
*There are many historic buildings in the old town and inland harbour of Glückstadt. Christian IV, king of Denmark and Norway and duke of Schleswig and Holstein, founded the town in 1617.*

**Below:**
*Glückstadt was created on the drawing board and has a practically hexagonal plan. The historic town hall (1642) on the market place is sadly no longer original. A new building was erected here in 1873 under the Prussians, the facade of which is an exact copy of the first design.*

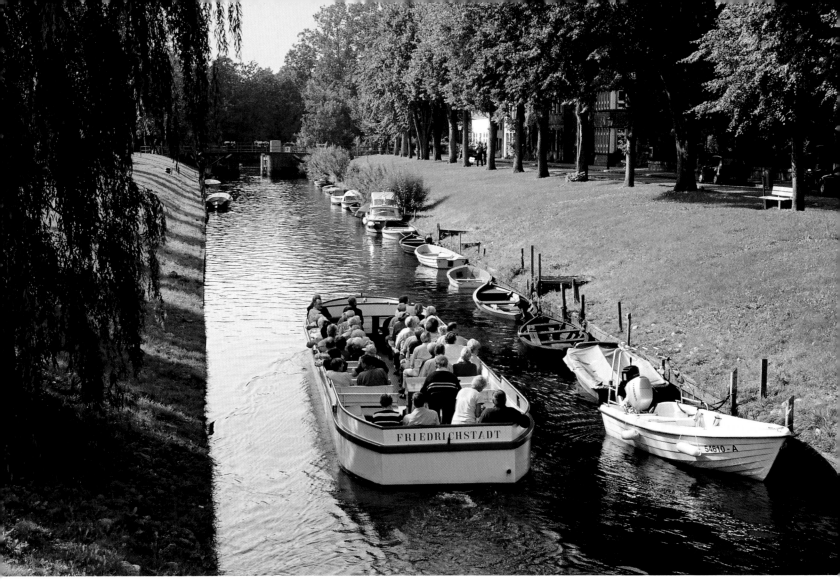

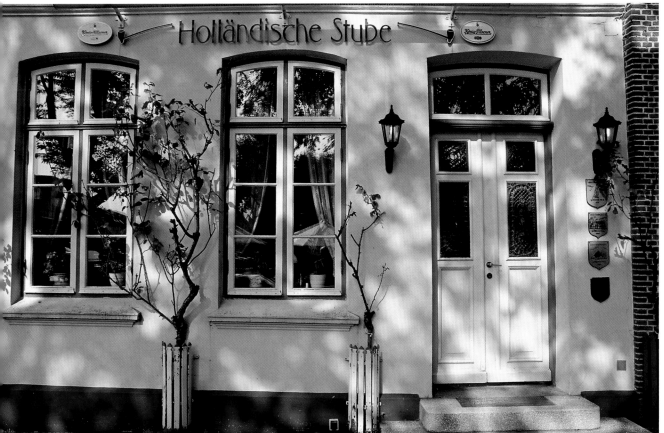

**Above:**
Boat trip on the Mittelburggraben near Friedrichstadt. The town lies between the Eider and Treene rivers which are linked by a system of sluices and canals. The Mittelburggraben divides the south from the north half of the town.

**Left:**
Lots of Dutch people settled in Friedrichstadt, earning the town the epithet of Little Holland. One of the most splendid old houses, erected between 1621 and 1625, now houses the Holländische Stube restaurant.

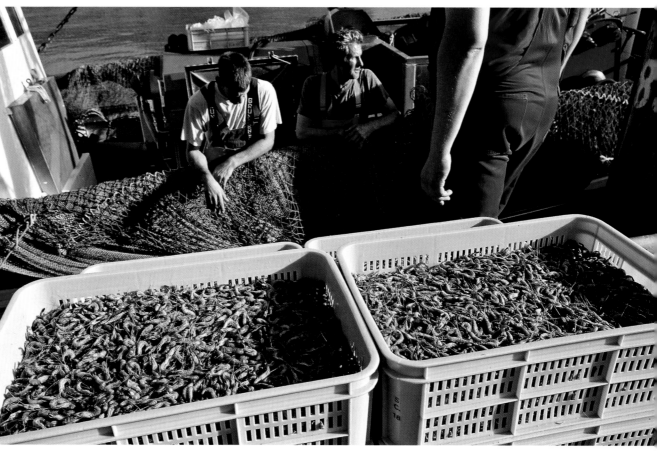

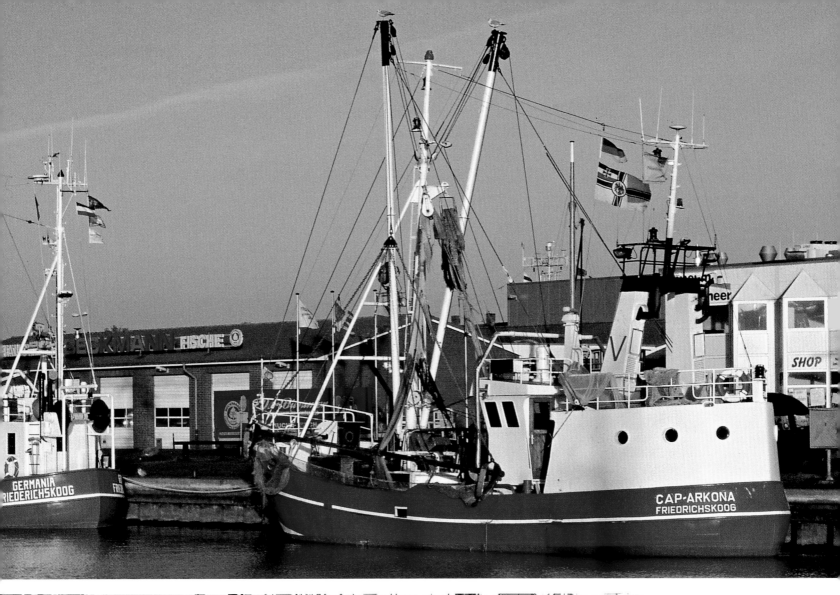

**Left:**

*Shrimp cutter in Büsum's inland harbour. After Brunsbüttel the town has the biggest harbour on the North Sea coast of Schleswig-Holstein. The open sea is accessible by means of a tidal current, known locally as the Piep.*

# *LABSKAUS* AND *GRÖÖNER HEIN*: NORTH GERMAN SPECIALITIES

The cooking in Schleswig-Holstein has traditionally been basic yet nutritious, designed to provide hardworking farmers and fishermen with plenty of energy. It was originally influenced by its neighbours of Lower Saxony and Denmark – and, not surprisingly, by the sea. Maritime delicacies are of course now commonplace in supermarkets all over Europe; nowhere else are they as fresh as on the coast, however, with lobster from Helgoland, oysters from Sylt, shrimp from Büsum, mussels from the Hallig Isles, sprats from Kiel and young herring from Glückstadt just a few of the choice items on local menus. There's also pike, pikeperch and eels, deliciously smoked over fires of beech and alder wood. Holstein ham and the countless types of cheese available here are also very tasty.

One dish indigenous to North Germany is *Labskaus*, which has been a seaman's staple since the 18th century. It consists of salt meat or corned beef, young herring, salt gherkins, onions and beetroot. The combination is put through the mincer, fried and mixed with boiled, mashed potatoes. To make it look more attractive, it's then garnished with rollmops, fried eggs and cucumber. Maybe the rather mushy Labskaus was the only way to still the hunger of men who had been at sea for months on end and lost their teeth to scurvy ...

Another quirk peculiar to the chefs of Schleswig-Holstein is the permutation of sweet and sour or spicy, known locally as *broken Sööt* or "broken sweetness". One such recipe is a stew known as *Grööner Hein* which combines pears, beans and dried bacon. A similar concoction is green cabbage and sausage or smoked pork loin, served with fried, caramelised potatoes.

### Karkensupp and Schnüüsch

*Karkensupp*, "church soup", is a broth made of pearl barley, sultanas and wine which was dished up on high days and holidays with ham and *Mehlbüddel*. The latter, also called a *Großer Hans*, is a huge dumpling often wrapped in a linen cloth and steamed in a bain-marie. It can be served with sugar, melted butter, stewed fruit, such as sour cherries, and slices of pork cheek.

The amazing sounding *Schnüüsch* is a vegetable soup of beans, peas, potatoes, kohlrabi and carrots boiled in milk. *Rübenmalheur* is a stew made of swede, carrot and potato. Holstein *Sauerfleisch* is pork boiled in white wine vinegar with bayleaf, caraway seed and juniper berries. When cold the liquid turns to jelly, making a delicious brawn.

Fish and pork are the prime choices of meat up north, but you can also find lamb, beef and poultry on the table. On days when the animals were slaughtered pig's blood was boiled up with vinegar and spices to make *Swattsuer*, the poor man's fare of the days of yore.

One starter which doubles as a dessert is *Fliederbeersuppe*, a soup made of elderberry juice and bits of apple with semolina dumplings floating in it. *Friesische Bohnensuppe* or Frisian bean soup is not what it seems; it is, in fact, sultanas in alcohol. It's served as a sweet sauce, dribbled over vanilla ice cream, for example. Another speciality initially from North German is the nationally popular *rote Grütze* or stewed red fruits and berries.

All of the above are inevitably washed down with beer, corn schnapps or *Köm*, aquavit with caraway. Country folk in the pub order a *Lütt und Lütt*, a little beer and a shot of *Korn*. In the areas where the wind and rain do their worst and warmth in whatever form is always welcome, grog is extremely popular. One failsafe recipe for the X-rated version is "Rum mutt, Zucker kann, Woter deit nich not"; rum is a must, sugar an option and water not necessary. Another variant is eggnog, where egg yolk and sugar play down the hefty alcoholic content. A dead aunt or *tote Tante* is brought back to life on drinking hot chocolate mixed with rum and cream; if coffee is substituted for the chocolate, the tipple is called a *Pharisäer* or pharisee. The latter is said to have originated on the island of Nordstrand where a parson adverse to drink once held office. At a christening the hosts drank the usual cup of coffee laced with rum, placing a good dollop of cream on top so that nobody could smell the alcohol. The guests enjoyed their little misdemeanour while the vicar sipped his coffee neat – until by accident he was given the spirited rendering, upon which he muttered with a glazed smile "You hypocrites!"

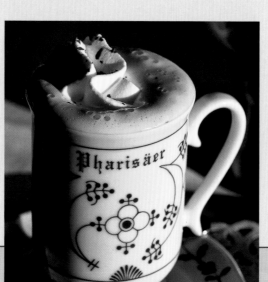

**Left:**
Spiced up with rum and served with a good dollop of cream, Pharisäer coffee is the national drink of North Frisia.

**Above:**
Fish restaurant Gosch in List on the island of Sylt has everything the fish-lover's heart (and stomach) desires, from tasty fish rolls to gourmet three-course meals.

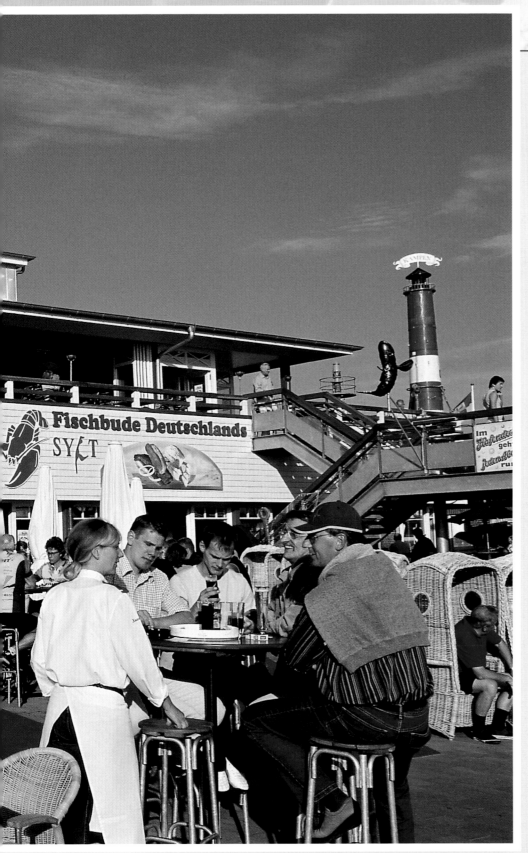

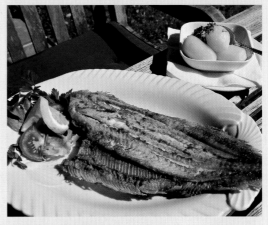

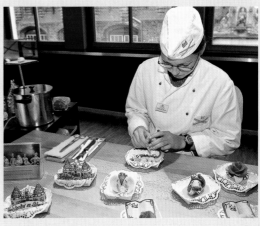

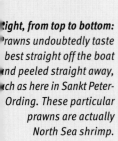

*Right, from top to bottom: Prawns undoubtedly taste best straight off the boat and peeled straight away, such as here in Sankt Peter-Ording. These particular prawns are actually North Sea shrimp.*

*A good, hearty Hallig Isles Platter, served here on Hallig Hooge.*

*At the Godewind or "good wind" fish restaurant in Tönning on the mouth of the Eider you can have as much plaice as you can eat!*

*Making marzipan at Café Niederegger in the heart of Old Lübeck. Sheer heaven for marzipan lovers, the café sells over 300 different varieties.*

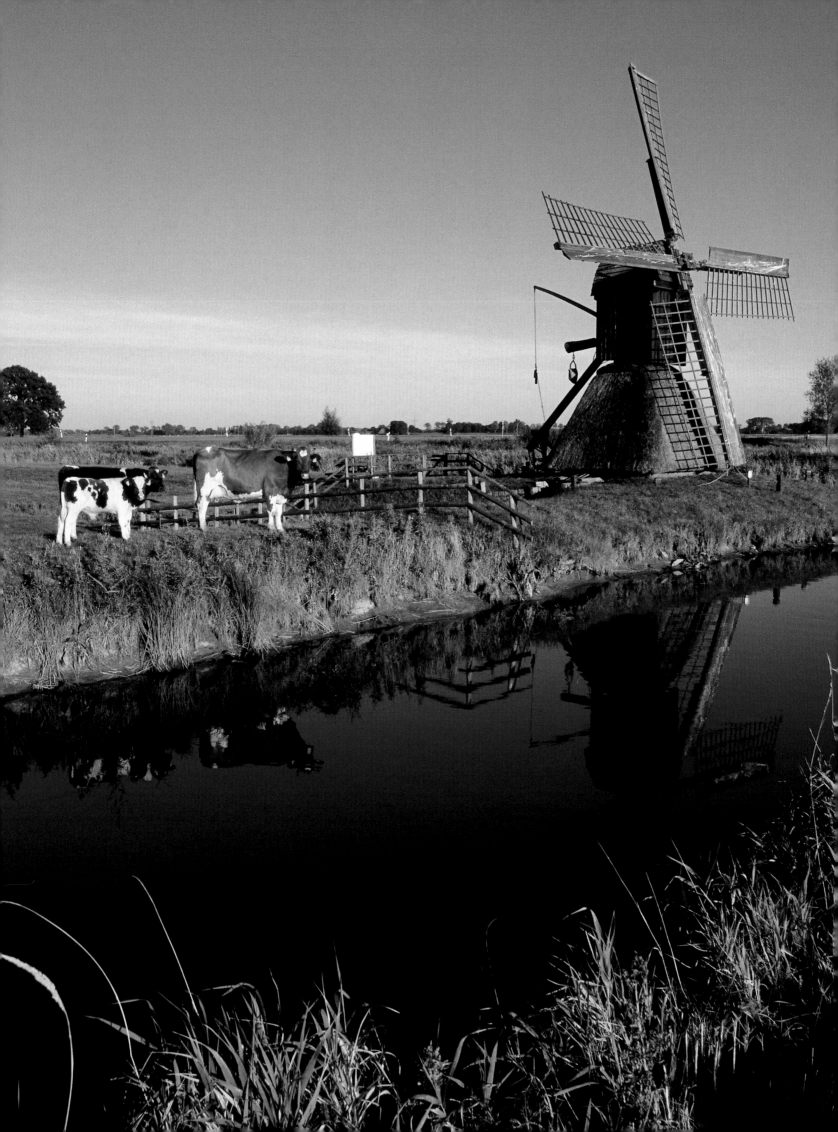

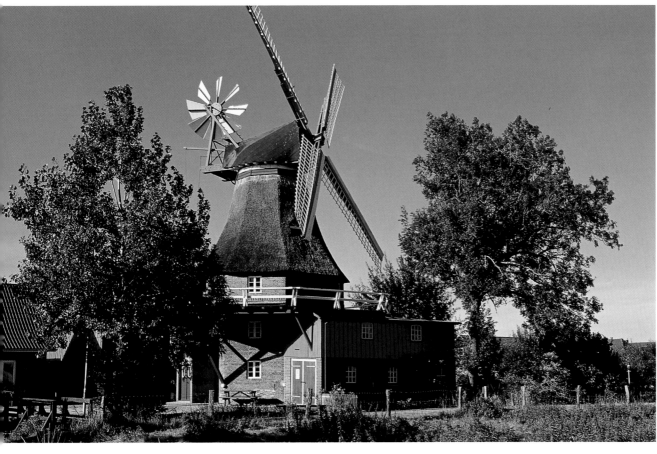

*Left page:*
*Much of Wilstermarsch is below sea level. In the past windmills powered the pumping stations which drained the land. This listed windpump near Honigfleth dates back to the mid 19th century and was restored just a few years ago. It's the last of its kind in Northern Germany.*

*The mill at Eddelak, called Gott mit uns (God be with us), is a smock mill and also a listed building. It was built in 1885. In 1997 the German post office featured it on a charity stamp.*

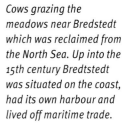

*Cows grazing the meadows near Bredstedt which was reclaimed from the North Sea. Up into the 15th century Bredtstedt was situated on the coast, had its own harbour and lived off maritime trade.*

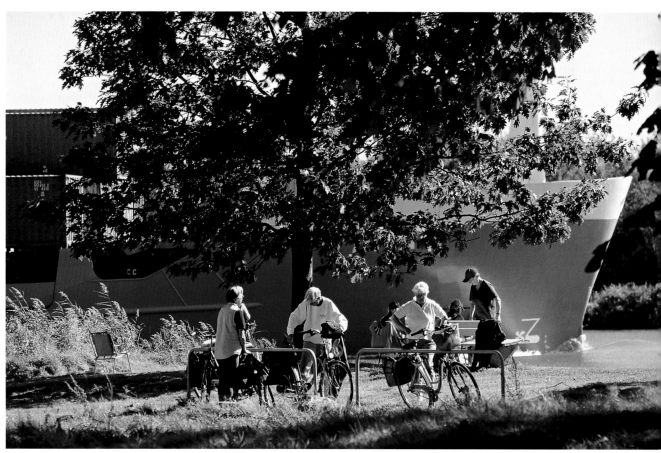

**Above:**
Freighter on the Kiel Canal near Kudensee. Opened in 1895, the channel cuts almost 99 kilometres (60 miles) through the heart of Schleswig-Holstein from the mouth of the Elbe to the Kiel Fjord and is the most-travelled artificial waterway in the world.

**Right:**
Cyclists on the Kiel Canal near Burg in Dithmarschen. Up until 1948 the channel was called the Kaiser-Wilhelm-Kanal after Emperor William II, who in 1902 levied a tax on sparkling wine to help pay for it.

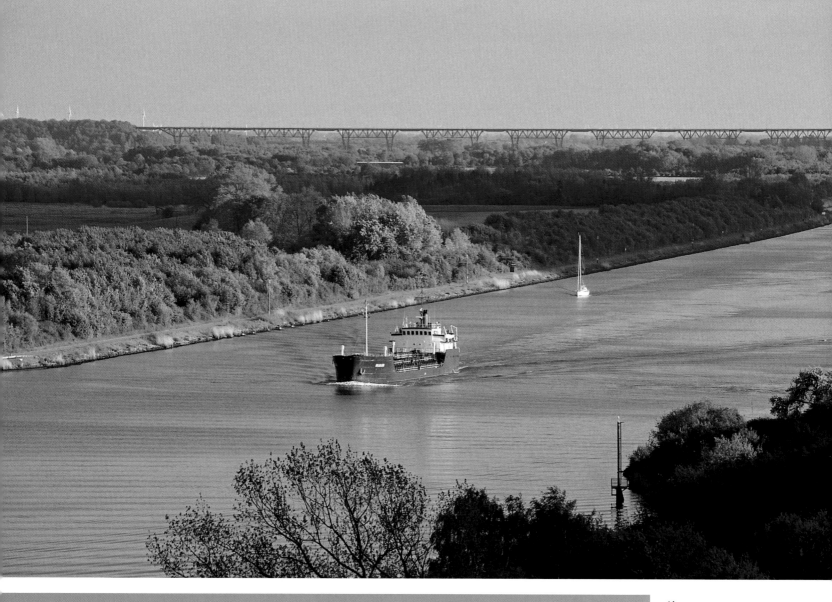

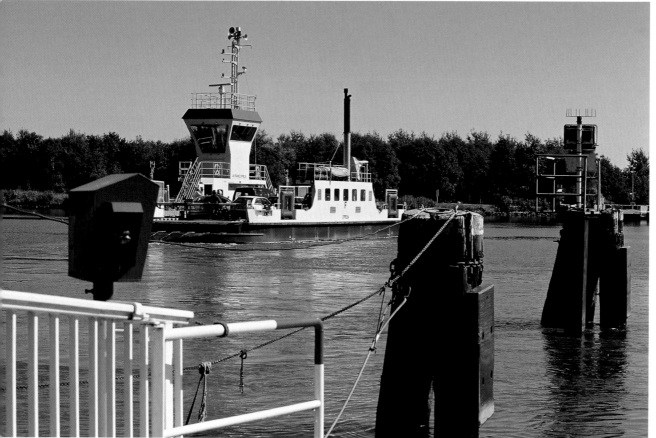

**Above:**
On the Kiel Canal near Brunsbüttel, along which around 43,000 ships passed in 2006. The canal has been altered several times during its history, the most recent amendments being its present extension to a width of 162 metres (532 feet).

**Left:**
One of the many ferries serving the Kiel Canal near Burg in Dithmarschen. Crossing the canal by ferry is free – as decreed by Emperor William II.

**Page 40/41:**
The inland harbour in Husum. When in 1362 the Second Flood of St Marcellus or the Grote Mandrenke washed away much of the coastline, Husum became a harbour town practically overnight.

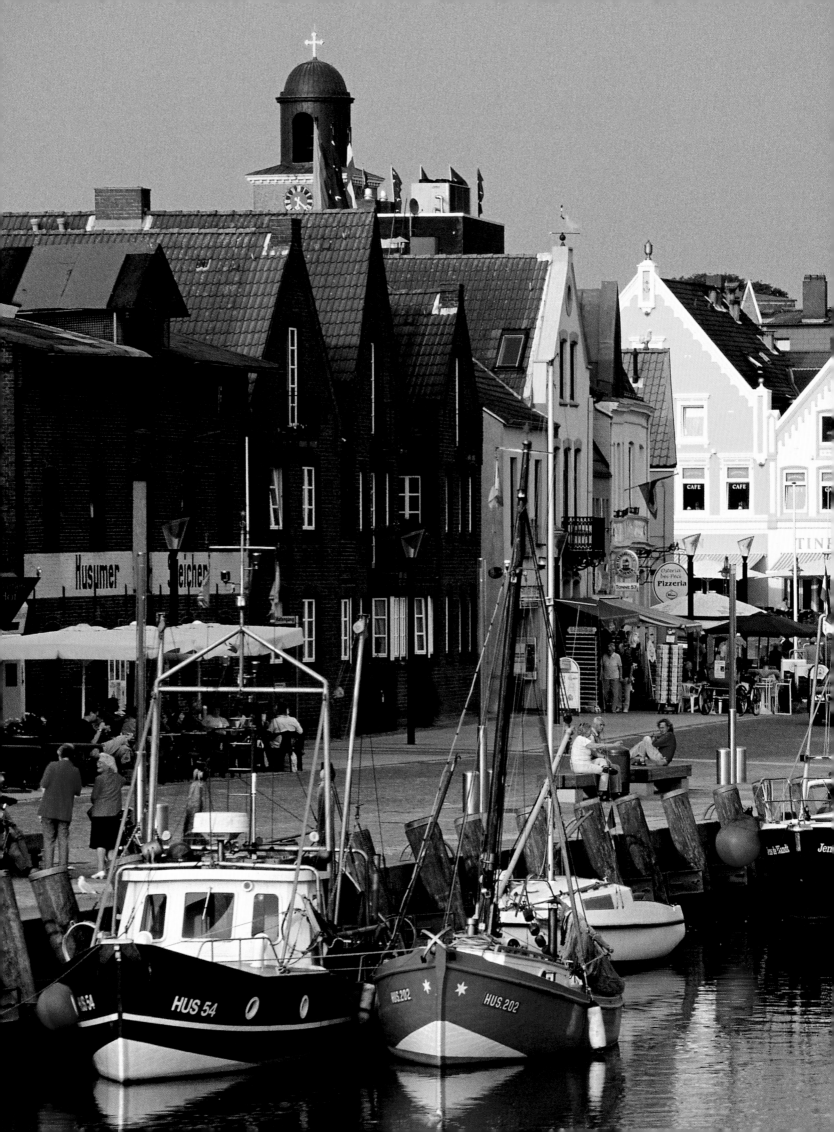

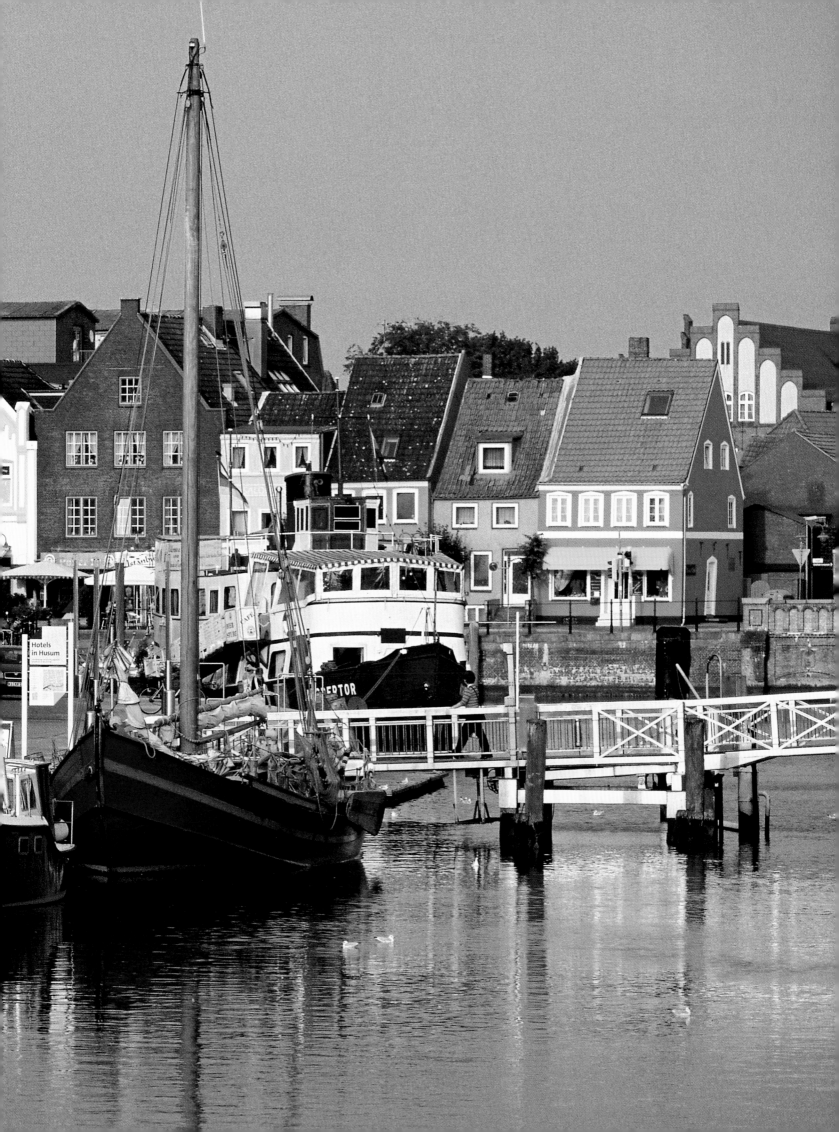

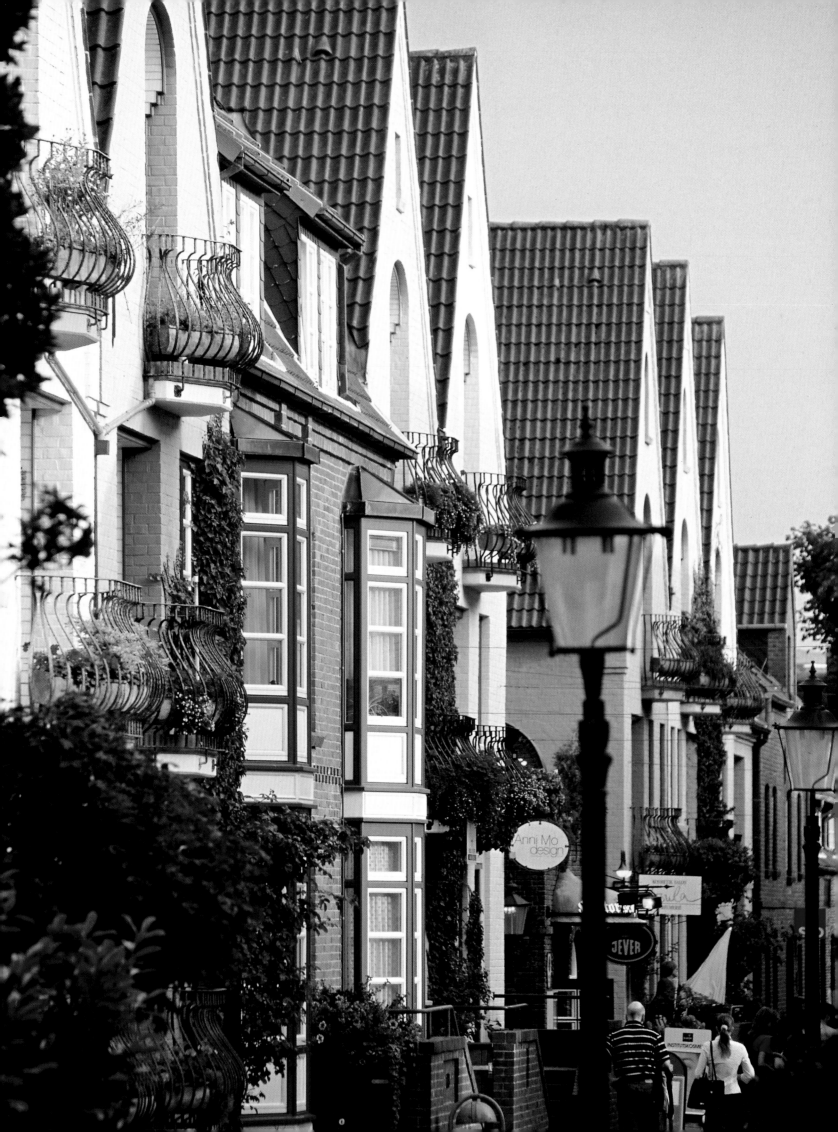

The Schloss vor Husum, the palace outside Husum, was thus called because at the time of its construction it lay beyond the town boundaries. It was built between 1577 and 1582 by a half-brother of the Danish king Christian III, Duke Adolf of Schleswig-Holstein-Gottorf. After falling under Prussian administration in the wake of the German-Danish War in the 19th century, the local council of the district of Husum and the district court moved into the palace. Theodor Storm was district court judge and court councillor here from 1867 to 1880.

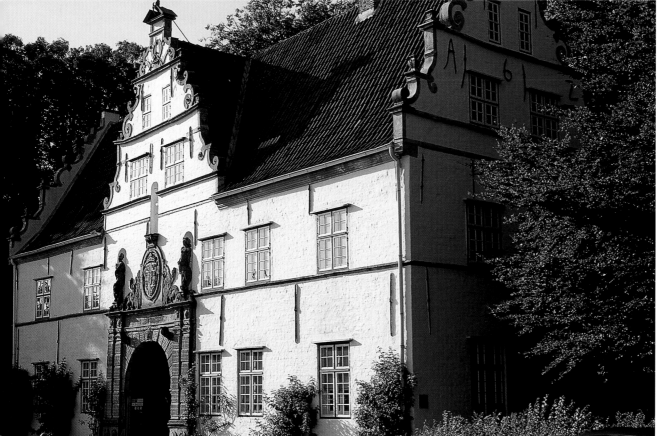

The palace gatehouse. The Schloss vor Husum is now used for cultural purposes: as a museum, as the seat of the music conservatoire and for exhibitions, concerts and plays.

**Left page:**
Schlossgang in Husum is a pedestrian zone which runs from the market place outside the Marienkirche to the palace. The architecture of the new houses and shops here has been carefully designed to match that of the old town.

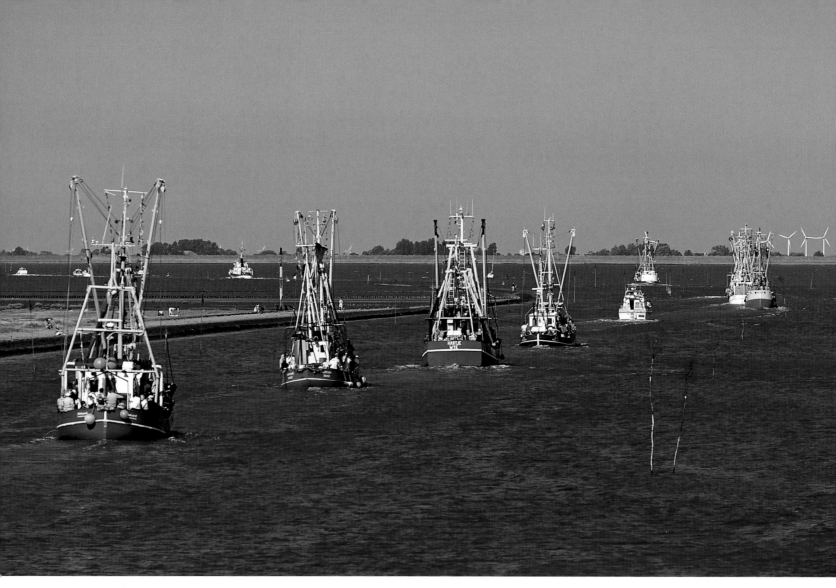

Bright and lively with a distinct maritime flair is how Theodor Storm's "grey town" presents itself in August at the annual Husumer Hafenfest. Thousands flock to the harbour to enjoy the various events: the cutter parade (above and right), the crafts market and live music – not to mention the tug-of-war matches and shrimp peeling competitions. The big bash is rounded off by a spectacular firework display.

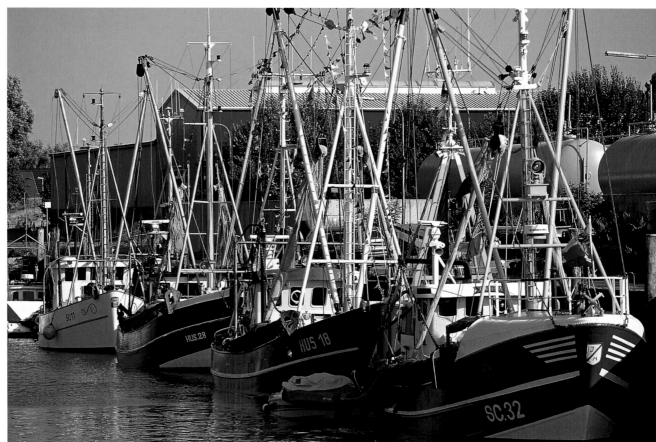

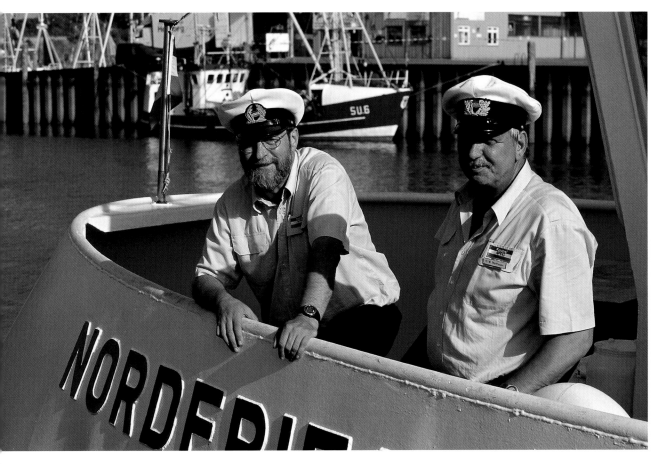

**Page 46/47:**
*Visible for miles around, the Westerheversand lighthouse is undoubtedly the most distinctive feature of the Eiderstedt Peninsula. Erected in 1906, it consists of 608 cast-iron plates weighing 130 metric tons. It was restored and generally spruced up for its hundredth birthday.*

**Left:**
*Captain (right) and first mate aboard the Nordfriesland pleasure steamer in Husum harbour.*

**Below:**
*A freight ship near Husum during the cutter parade put on as part of the town's Hafenfest or harbour festival.*

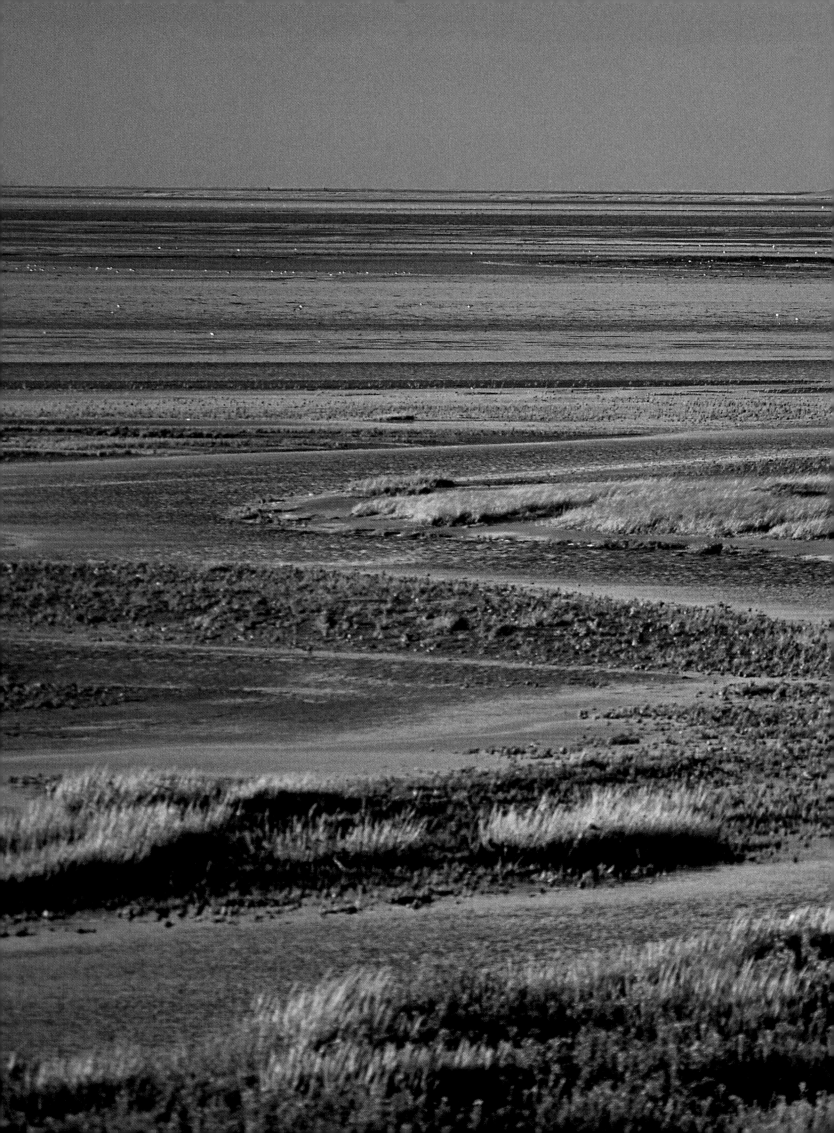

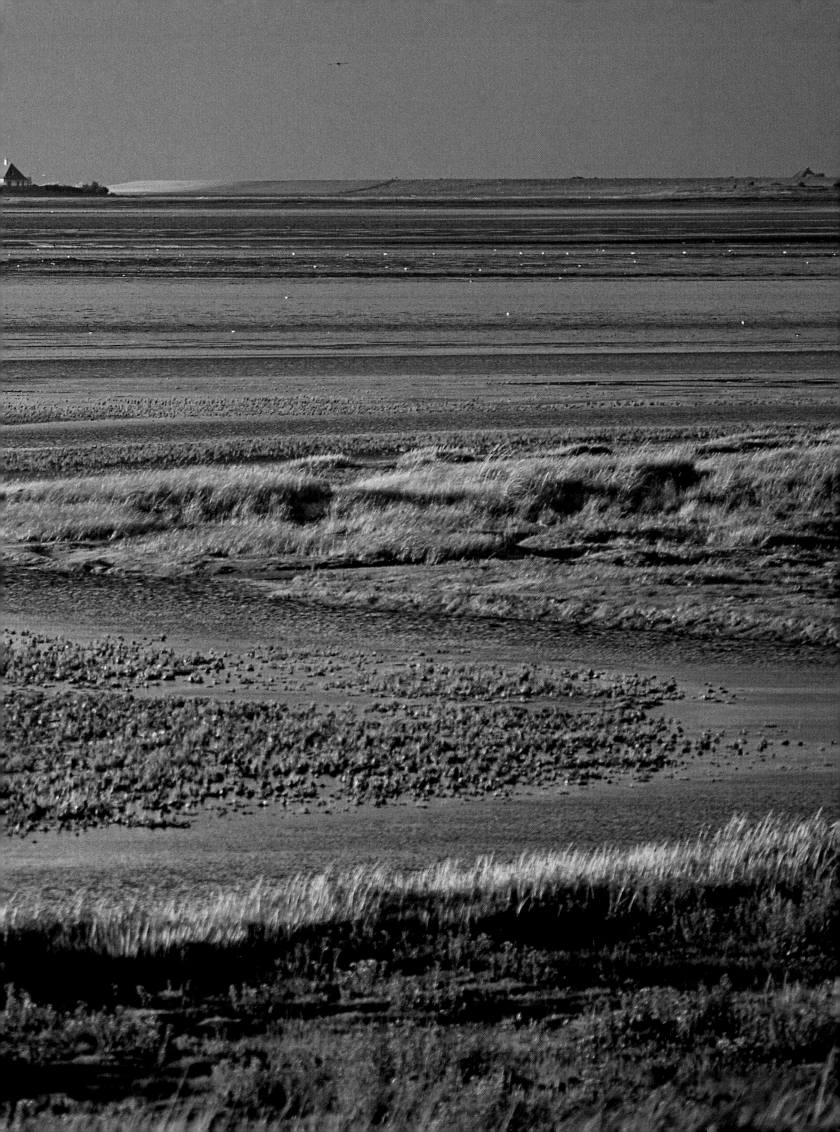

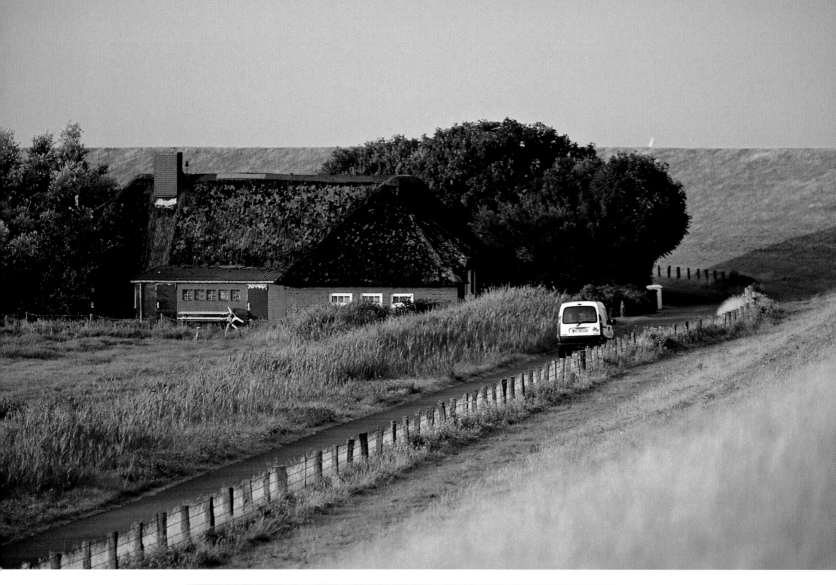

***Above:***
*Frisian house beneath a dyke near Westerhever on the northwest tip of the Eiderstedt Peninsula.*

***Right:***
*On the peninsula of Eiderstedt a typical farmhouse is called a Haubarg or a place where hay is stored. For centuries farmers shared houses such as these with their farmyard animals.*

48

**Page 50/51:**
*On the beach at Sankt Peter-Ording. Situated on the west tip of the Eiderstedt Peninsula, the town is the biggest seaside resort in Germany.*

**Left:**
*There are plenty of salt meadows on Nordstrand which provide seabirds with a place of refuge and good nesting areas. One of the delicacies of this part of the country is North Frisian salt meadow lamb which is particularly aromatic due to the grasses and herbs the animals feed off.*

**Below:**
*The brick church of St Stephen's is the focal point of the village of Westerhever, its Gothic tower dating back to 1370. The nave is much younger – from 1804.*

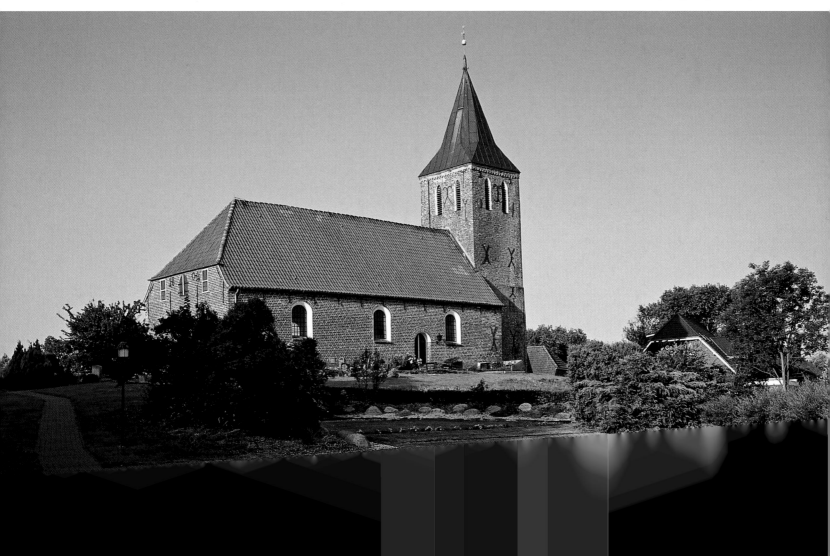

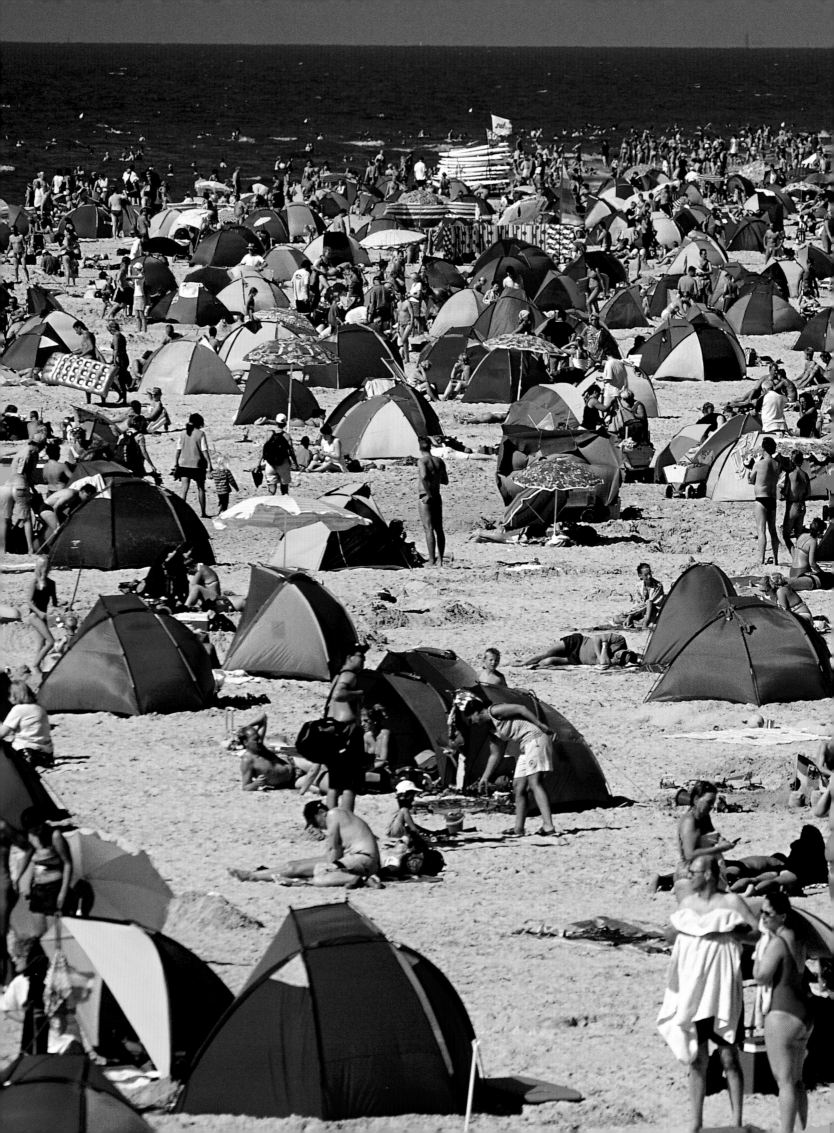

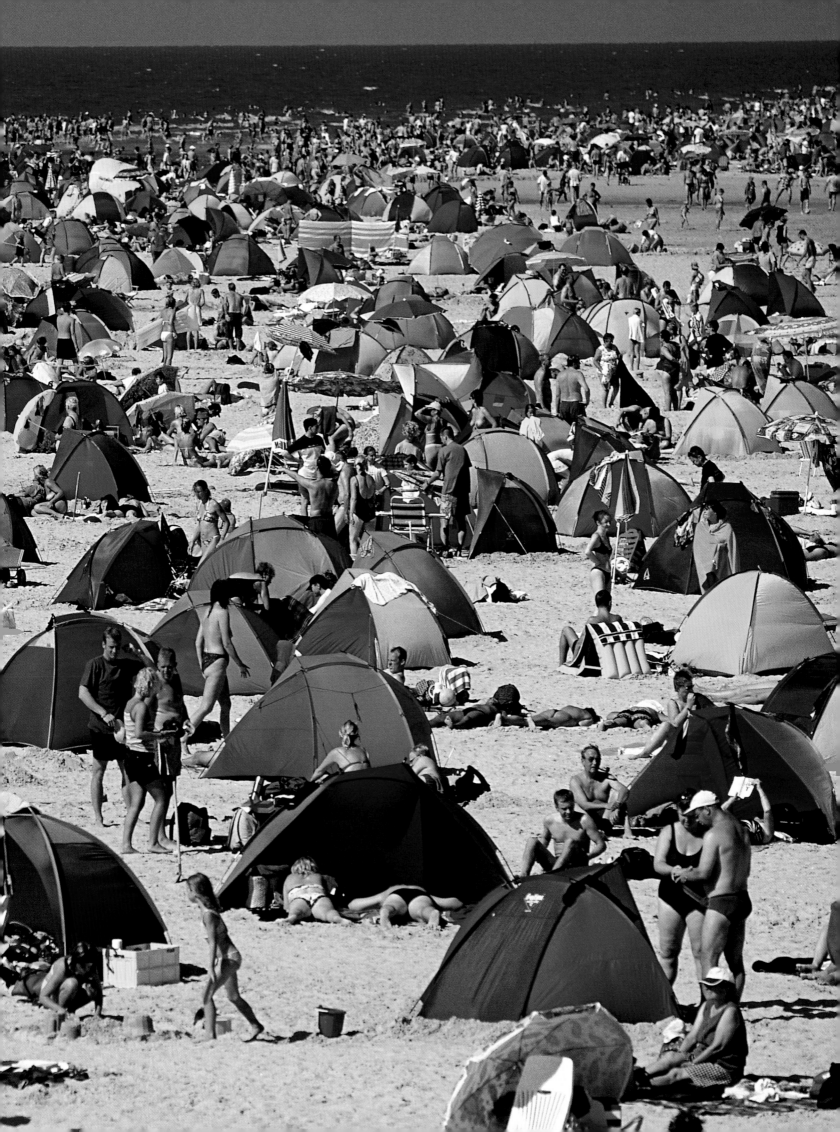

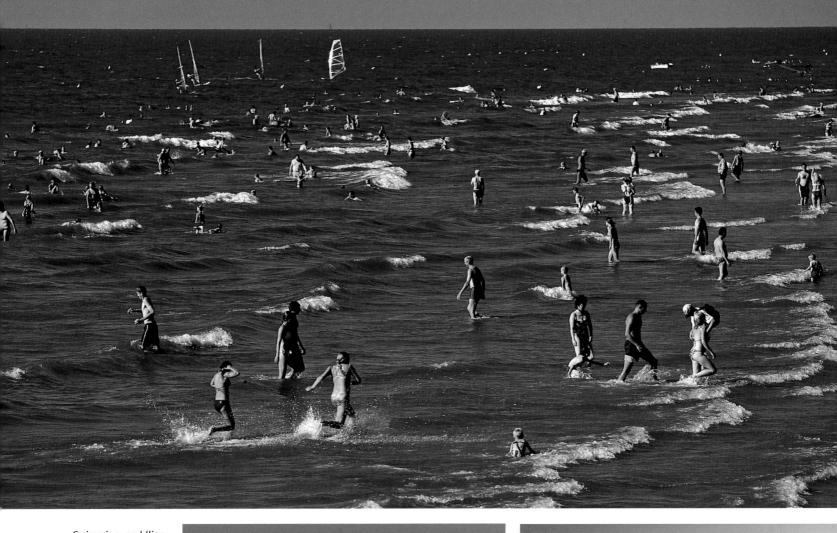

*Swimming, paddling, building sandcastles: what more could you want?! Holidaymakers both great and small can enjoy themselves on the beach at Sankt Peter-Ording, twelve kilometres (seven miles) long and a good half a mile wide.*

*Fun in the sand at Sankt Peter-Ording. The first hotel was opened here in 1877, the first sanatorium in 1913. The beach's characteristic log huts are up on stilts so that visitors can easily spot where they can buy something to drink.*

*If you fancy doing some-
thing more strenuous
than simply relaxing Sankt
Peter-Ording also has
surfing or horse riding on
the beach. There is also
an adventure pool with
saunas called the Dünen-
Therme, filled with salt-
water from the North Sea.*

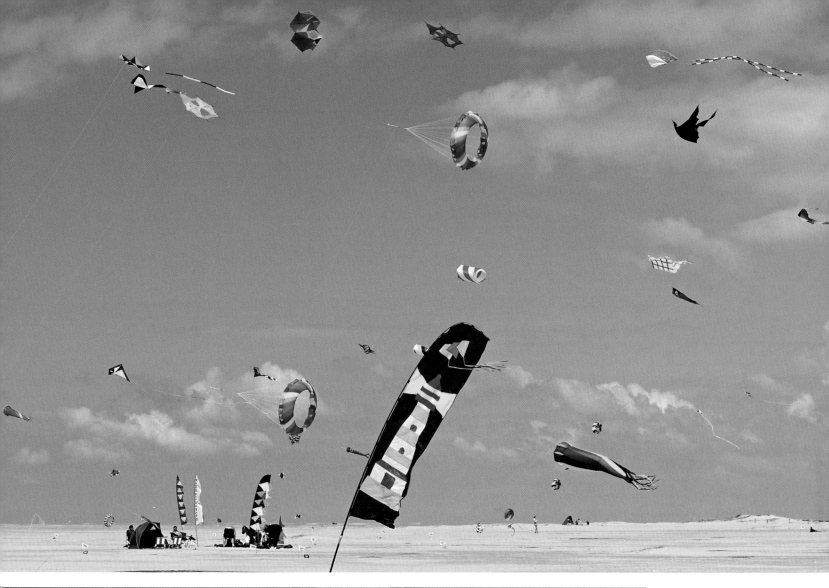

In Germany's northern-most federal state, tucked in between two oceans, the breeze is usually rather stiff. This is not used to generate wind power but also good for sand yachting and flying kites.

**Above:**
With around
5,000 inhabitants,
Tönning is the largest
town on the Eiderstedt
Peninsula. The market
place is surrounded by
pretty gabled houses
from the 17th and
18th centuries.

**Right:**
House front in the
harbour in Tönning,
with its typical blue-and-
white woodwork and
well-tended, bright and
breezy cottage garden.

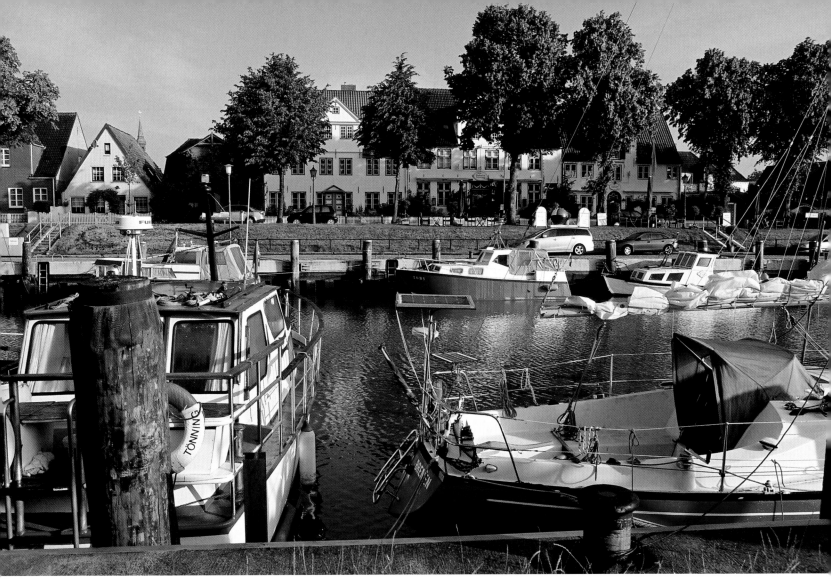

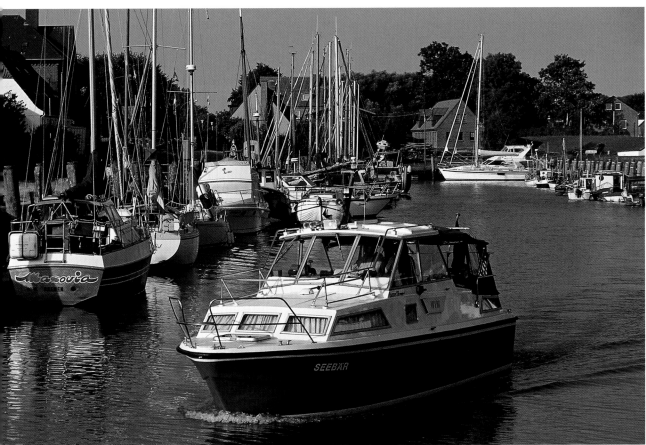

*In the harbour in Tönning. Many consider it to be the most beautiful harbour on the west coast of Schleswig-Holstein. It's a good place from whence to embark on trips along the River Eider, to the Eider Dam and the sandbanks inhabited by colonies of seals.*

# From Pellworm to Sylt: the North Frisian Islands

*Together with its twin List West, the elongated List Ost lighthouse on the Sylt Peninsula of Ellenbogen is the oldest cast-iron lighthouse in Germany. It went into operation on January 1, 1858.*

The offshore islands, Halligs and marshes of North Frisia are known locally as *Uthlande* or the outlands. This is where the map is constantly changing. Some of the islands have been thrown up by land masses cut off by floods over the centuries; others have been merged by manmade dykes and natural deposits of alluvial land, such as the Eiderstedt Peninsula.

Nordstrand, Pellworm and the three neighbouring Hallig Isles were formed in 1634 by a devastating storm tide which cost at least 8,000 human lives. A dam and the Beltringharder Koog, dyked in 1987, now link Nordstrand with the mainland. Pellworm has an average altitude of just one metre above sea level and would have long been relegated to the deep without its enormous dyke, eight metres (26 feet) high and 25 kilometres (15 miles) long. The Halligs are small islands on the Watt or Wadden Sea not protected by dykes. The farms and hamlets here are built on manmade mounds or *Warfte* in an attempt to protect them from the ravages of the sea.

One popular holiday destination is Föhr, the second-largest German island in the North Sea. In the lee of Amrum and Sylt vegetation on the island thrives, making it Germany's emerald isle. The resort of Wyk was founded way back in 1819. Amrum can be reached by car ferry from Wyk or Dagebüll. The chicest of the North Frisian Islands is Sylt. The 20,000 who permanently inhabit the 100 square kilometres (38 square miles) are joined by about 700,000 guests a year. The range of sports, leisure activities, shopping facilities and cultural events on offer here has urban proportions. With a bit of imagination the shape of the island is like a twirling ballerina, prompting journalist and artist Johannes Nikel to dream up a legend in which foreign gods tried to capture Odin's daughter, the beautiful sea goddess of Sylte. To escape their clutches she danced herself into a trance and turned into the island of Sylt ...

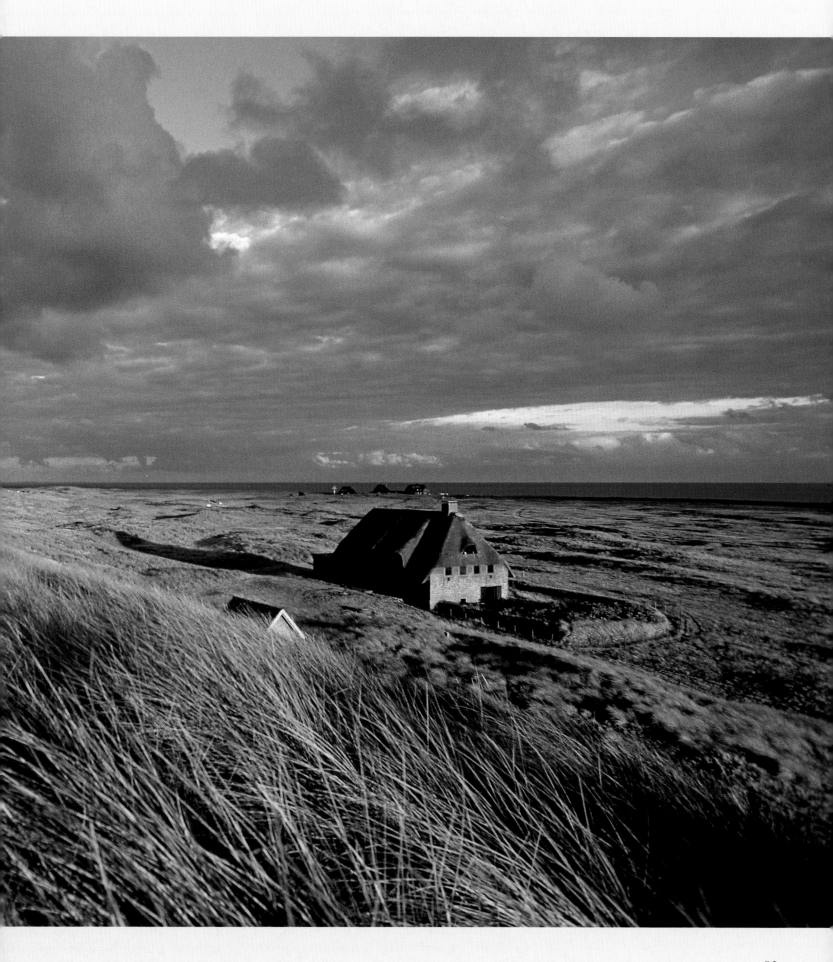

**Right:**
Dunes north of Kampen on Sylt. Until around a hundred years ago Kampen was devoted entirely to farming. It was discovered by tourists in the 1920s – and caused something of a scandal forty years later with its nudist beaches ...

**Below:**
The Blidselbucht is a bay between Kampen and List where the only oysters in Germany are farmed. Each mollusc has to be nurtured for three to four years before it's ready for market.

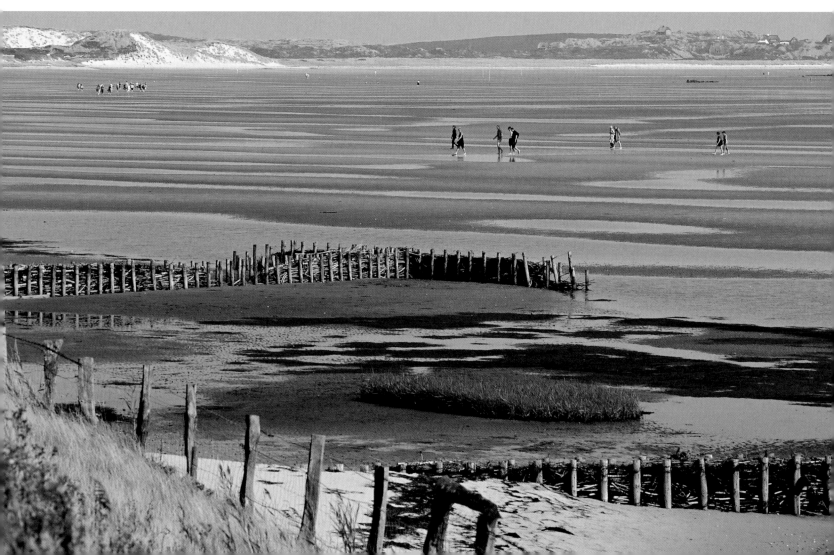

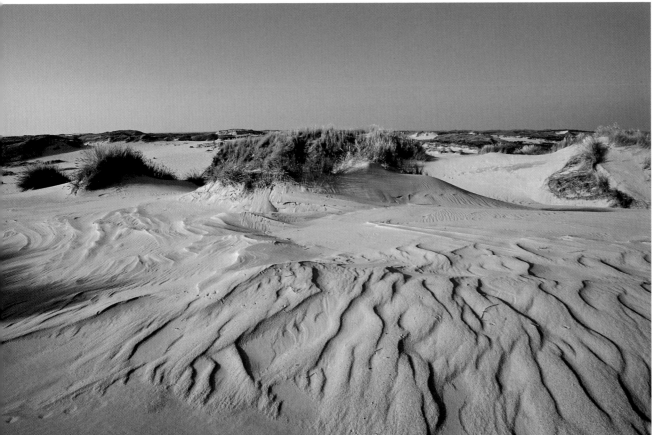

**Above:**
The Rotes Kliff is a steep cliff 52 metres (170 feet) high on the west side of the island between the towns of Wenningstedt and Kampen. For centuries mariners recognised the island by its distinctive rusty red precipice. Today the cliff is largely covered in sand dunes.

**Left:**
There is even a Sahara Desert on Sylt! It lies west of List, is approximately two kilometres (one mile) long and boasts temperatures of up to 50°C in summer. This is where you will find the only shifting sand dunes in Germany. The area was made a protected nature reserve in 1923 and cannot be accessed.

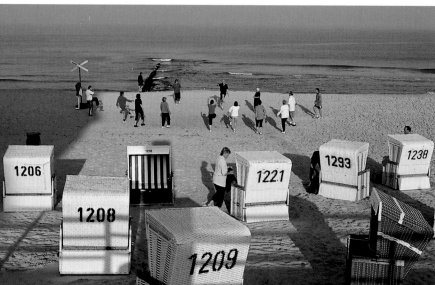

**Top left:**
*Stage on the beach promenade in Westerland. Music has livened up the goings-on here since 1879,*

*with around three hundred concerts of all musical genres performed from May to October each year.*

**Centre left:**
*Keeping fit at a mornin. workout in the fresh sea air on the beach at Westerland.*

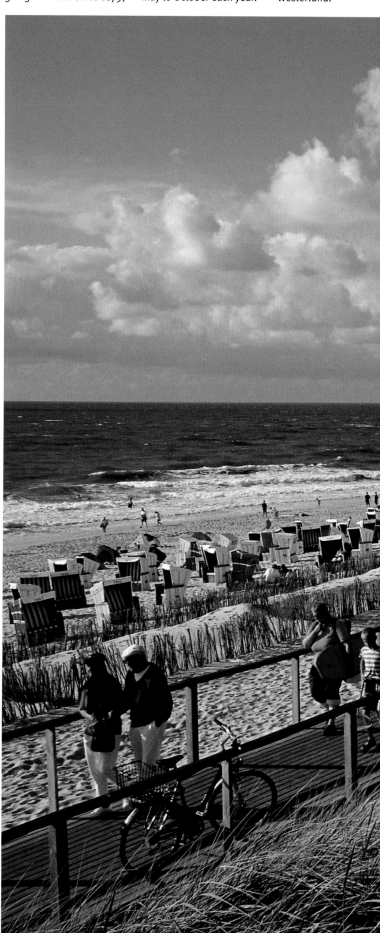

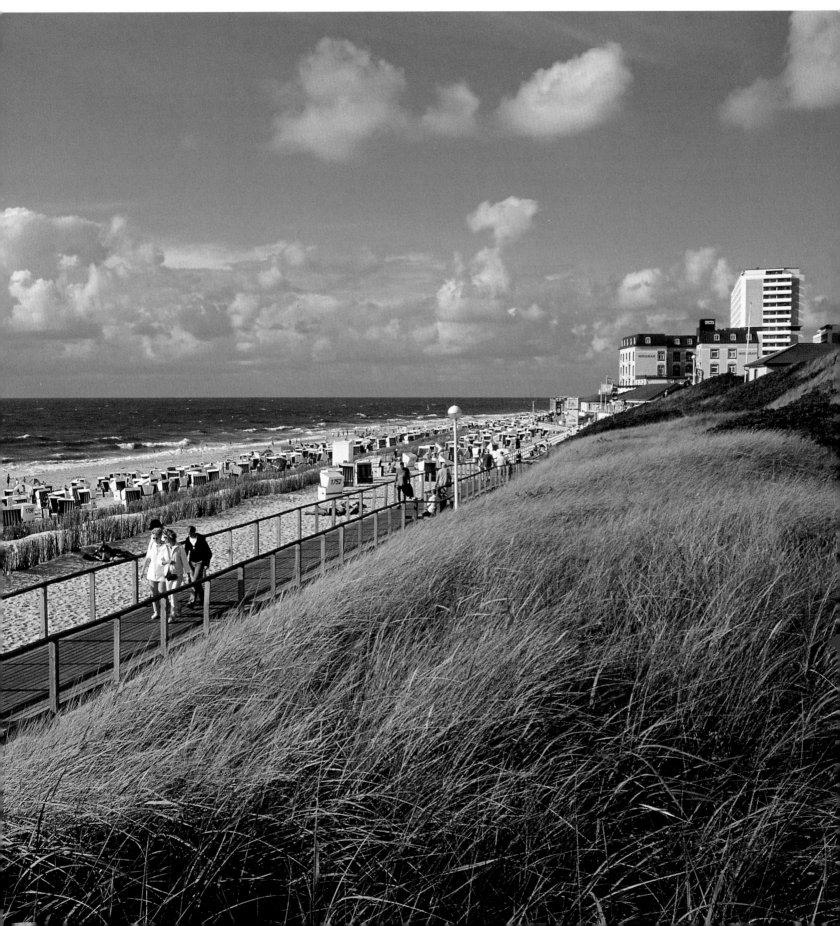

**rom left:**

can also soak up
sun in the harbour at
, the northernmost
munity in Germany.

**Below:**
The beach at Westerland.
Towards the end of the
18th century Westerland
was still a poor village
with a population of just
500 who could hardly raise
enough money to restore
their church. In the 1920s
the tide turned and the
village became a chic
seaside resort.

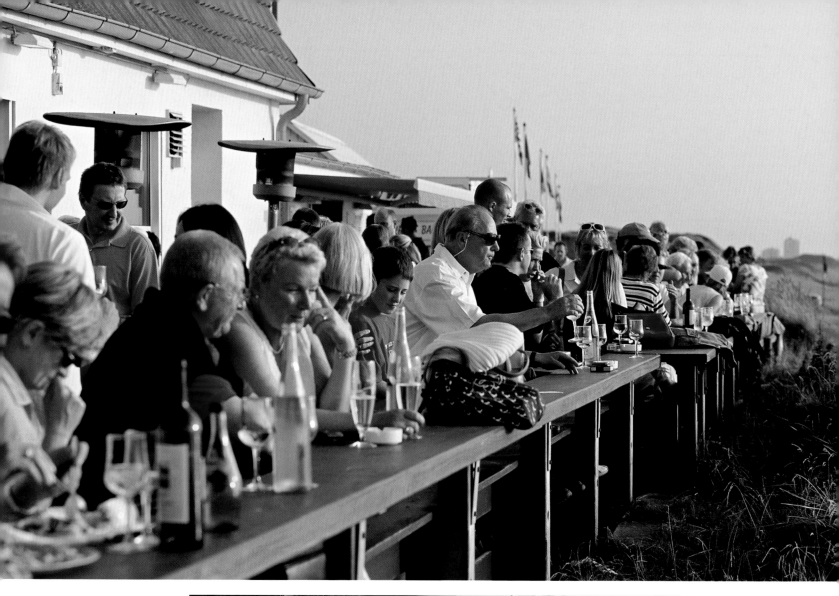

**Above:**
*At the Gosch am Kliff restaurant in Wenningstedt south of Kampen. The building is right on the cliff and has marvellous views out across the beach, the sea and the sunset.*

**Right:**
*This café-cum-restaurant in Keitum is known as the Landschaftliches Haus or country house. Its specialities are game and fish.*

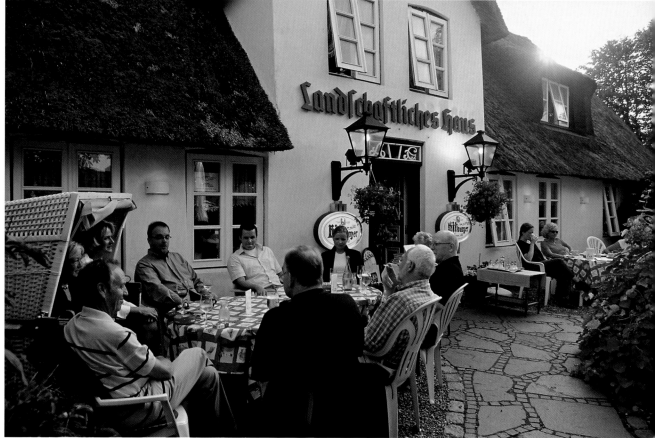

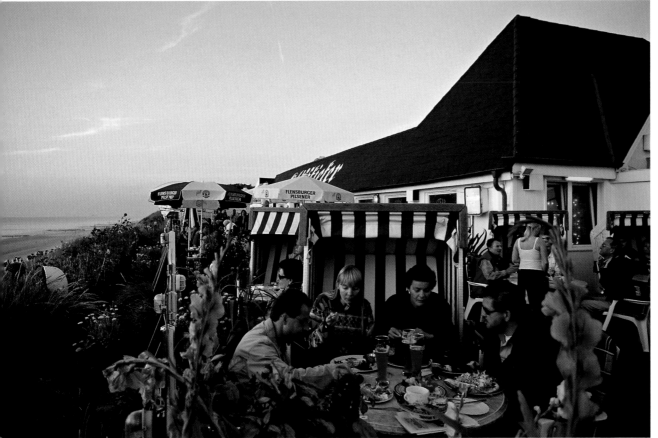

**Above:**
The pub Greta's Rauchfang on Strönwai, the "whisky mile" of Kampen, is a local institution. This is where many famous faces and playboys have turned the night into day over the past few decades.

**Left:**
The precipitous location of Gosch am Kliff in Wenning-stedt is absolutely unique. Those with a good head for heights can tuck into shrimp rolls, scallops and prosecco whilst admiring the spectacular views of the sea.

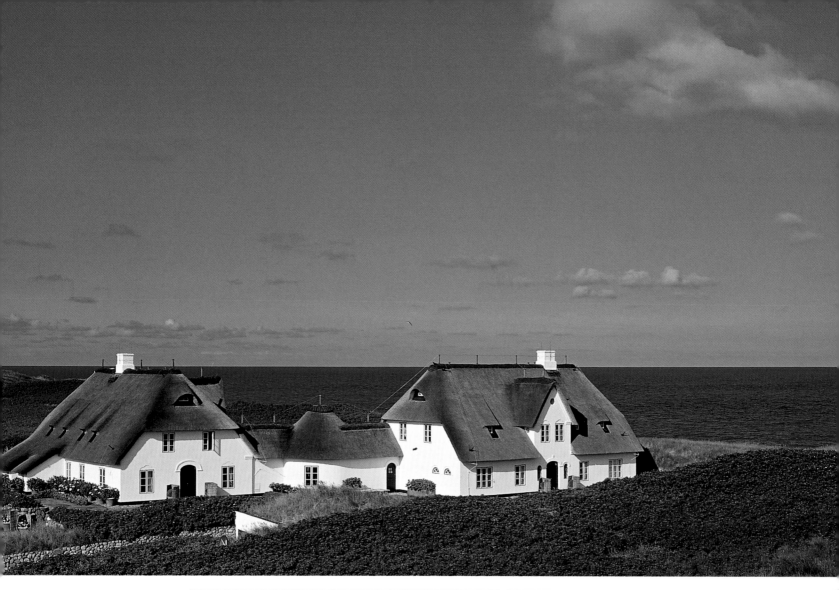

**Above:**

In the Kampener Heide. At the beginning of the 20th century Kampen attracted a multitude of artists and intellectuals. The thatched cottage of Kilffend, for example, was sometime home to the likes of Emil Nolde, Max Liebermann and Gustav Stresemann. Thomas Mann was even moved to write in its guest book: "I have lived deeply on this shattering sea."

**Right:**

The Alte Friesenstube guest house in Westerland is the oldest building on the island. Dating back to 1648, it's absolutely charming with its stylish furnishings and lovely garden. On fine days you can eat outside amongst the glorious roses.

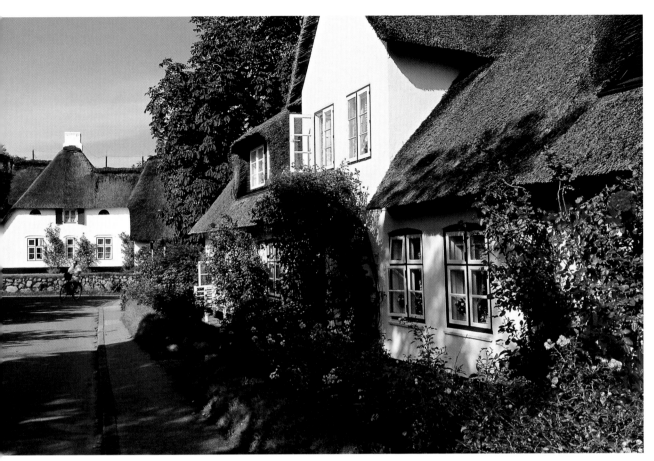

*Page 68/69:*
*View of Hörnum. Sylt's southernmost spit of land is constantly shrinking due to erosion, with the sea reclaiming up to 20 metres (65 feet) of coastline in years with frequent storm tides.*

*Left:*
*Frisian houses in the idyllic centre of Keitum. Up until the mid 19th century when tourism hit the island Keitum was the main town on Sylt. Its many trees and avenues make it the greenest town on the island.*

*Below:*
*The community of Hörnum clings to the south tip of Sylt. For centuries it was inhabited by just a handful of fishermen, with storm tides and shifting sand dunes making settlement practically impossible. On the evacuation of Helgoland in 1945 forty families from the latter set up home here.*

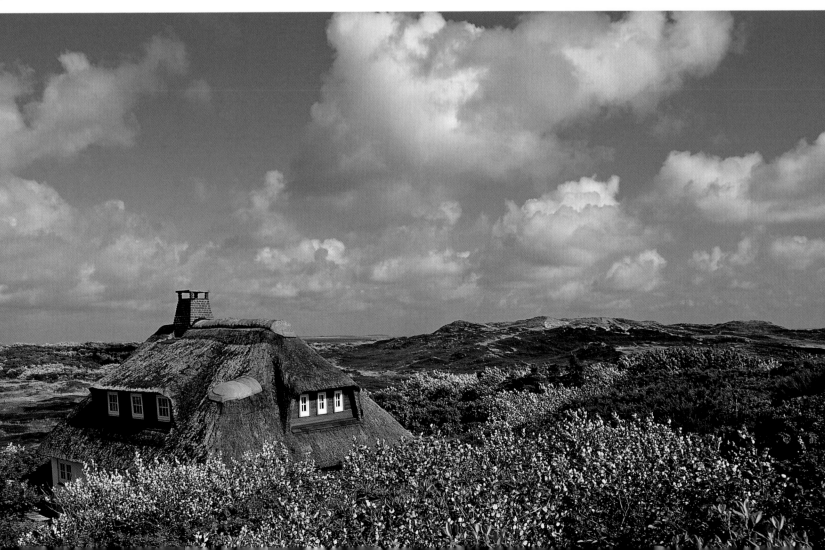

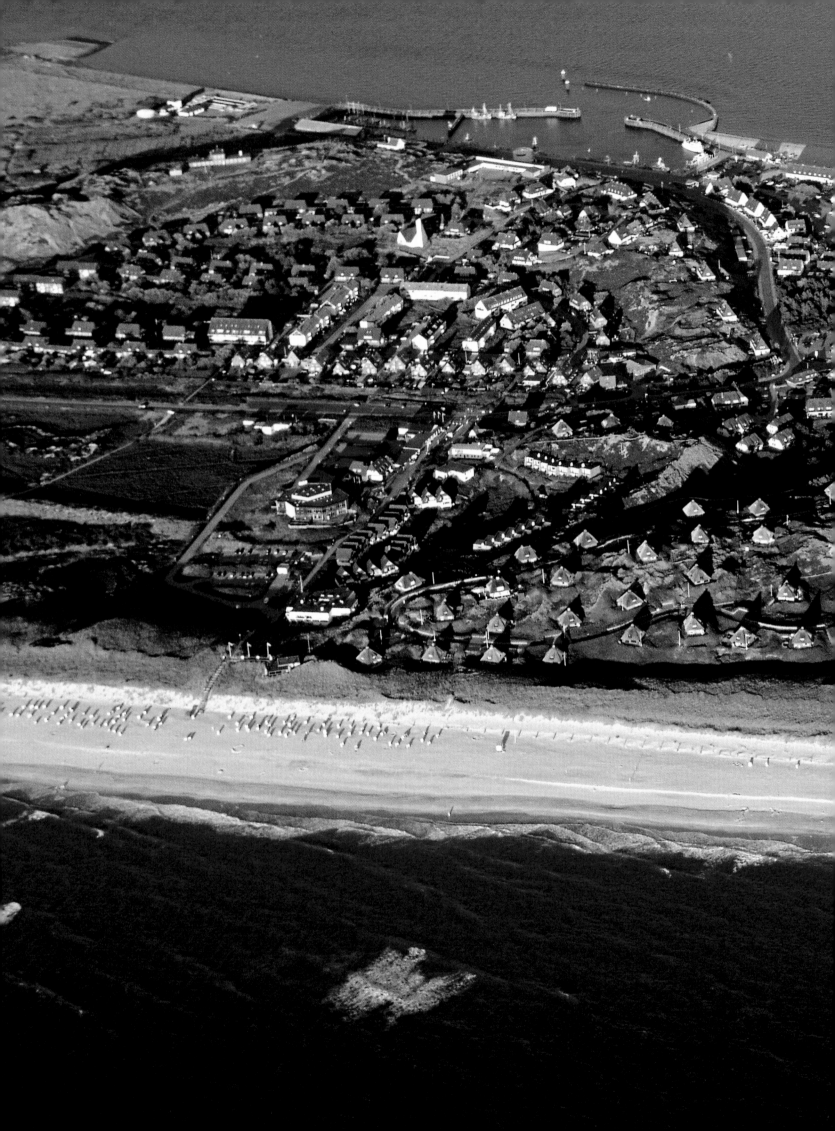

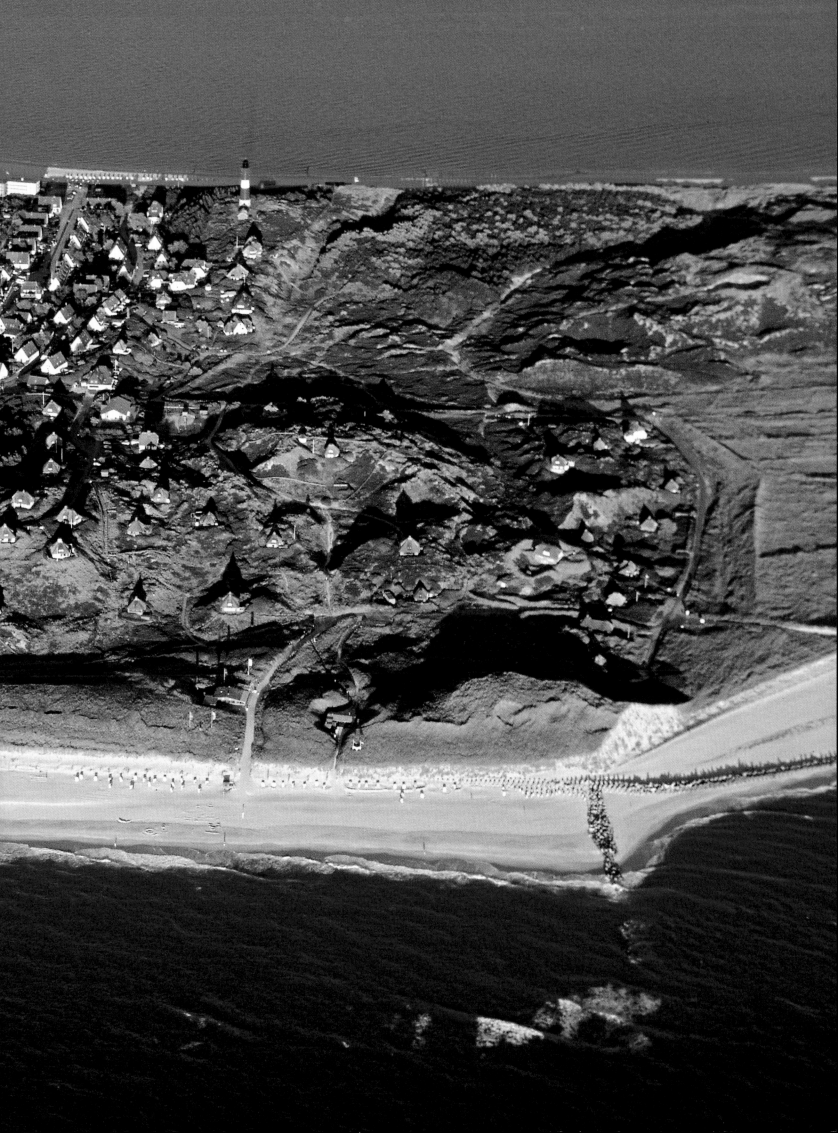

**Right:**
Mooring in Munkmarsch on the eastern shores of the island north of Keitum. The name means "monk's marsh" and probably alludes to a farmstead north of the church in Keitum during the 15th century.

**Below:**
In the harbour in Hörnum. The dunes are dominated by a huge lighthouse, 34 metres (112 feet) high, which is almost identical to those of Westerheversand and Pellworm. It goes back to 1907 and is made of cast-iron plates bolted together known as tubbings.

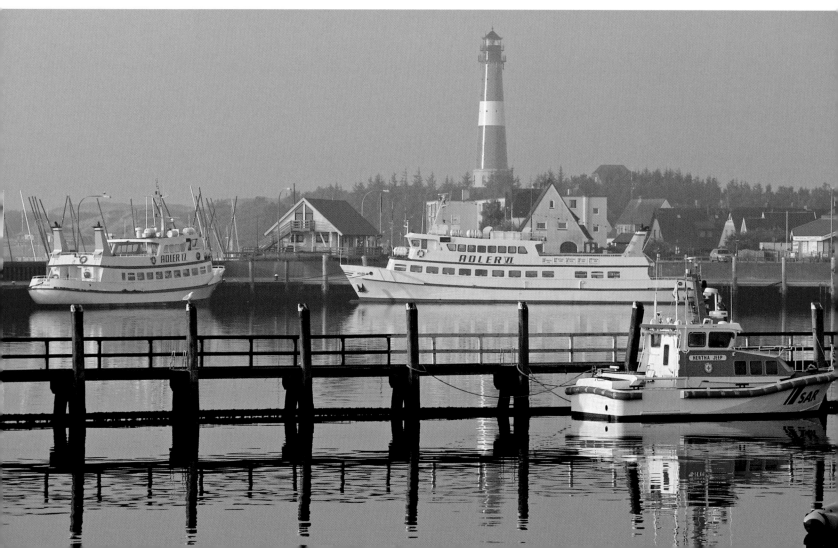

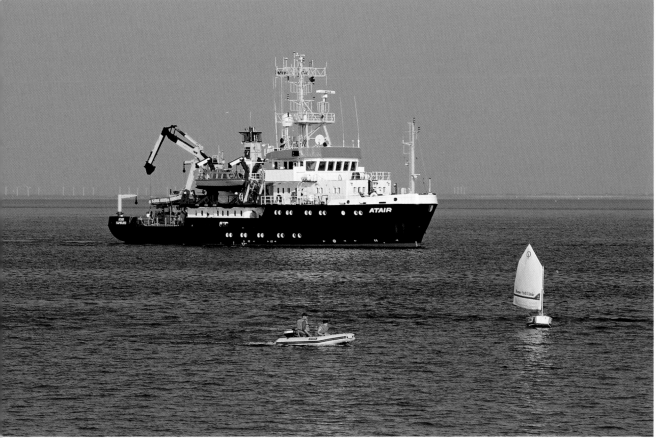

**Above:**
In the harbour in List. As the northernmost town in Germany List is part of the Zipfelbund, the alliance of the four German towns marking the geographical extremes of the republic: Selfkant in the west, Oberstdorf in the south, Görlitz in the east – and List in the north.

**Left:**
The Atair, a wreck search ship belonging to the Federal Office for Maritime Shipping and Hydrography (BSH). Each year wreck searches run by the BSH reveal up to 40 unknown wrecks and underwater obstructions which are charted on official nautical maps if they pose a hazard to shipping.

**Above:**
Café in the captain's village of Nieblum on the island of Föhr. Many of its splendid Frisian houses once belonged to ship's captains who made their fortunes as seafarers, often operating Dutch whalers.

**Right and far right:**
Two of the four windmills on the island of Föhr: in Wyk the smock mill Venti Amica ("the friend of the wind") from 1879 and in Wrixum a tower mill, built in 1851.

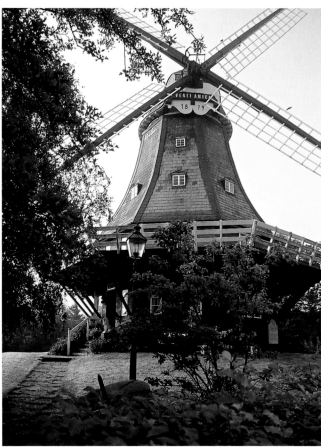

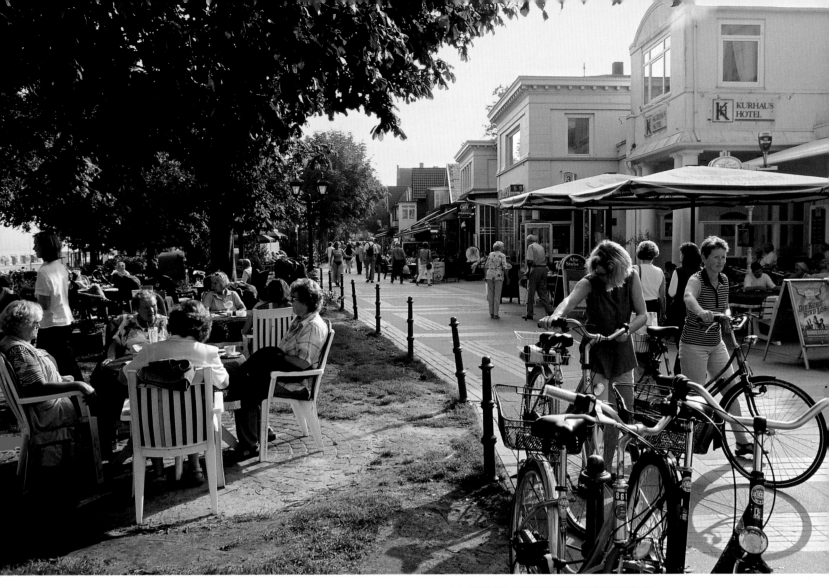

**Above:**
*Stockmannsweg
runs along the southern
shores of Wyk on Föhr.
Along the way is a salt-
water swimming pool
with a wave machine
called the AQUAFÖHR.*

**Far left:**
*The Borigsem windmill
near Borgsum on Föhr,
an octagonal smock mill
with a wind rose, is new.
It was erected in 1991
after its predecessor was
destroyed by fire.*

**Left:**
*There are also two
windmills on the island of
Amrum. The smaller of the
two goes back to 1775 and
is sited on a Bronze Age
burial mound called the
Reddenhugh in Süddorf.*

# SCHLESWIG-HOLSTEIN WRITES LITERARY HISTORY: FROM STORM TO LENZ

On a grey beach, on the grey sea / And to one side the city; / The fog weighs heavy on the rooftops ...": thus begins a poem by Theodor Storm (1817–1888) about his native town of Husum. The author of such a wide range of books – from children's stories to Christmas poems to novels such as *Immensee* and *Der Schimmelreiter* (The Dykemaster) – saw Husum for what it was, "[It is] just a plain town, my home town; its lies on a treeless coastal plateau and its houses are old and gloomy." And still his poem ends with a declaration of love: "Yet I love you with all my heart, / You grey town on the sea; / The magic of youth for ever and ever / Rests smiling on you, on you, / You grey town on the sea."

One of the best known Low German poets is Klaus Groth (1819–1899), born in Heide, Dithmarschen. His collection of writings in Plattdeutsch, Quickborn published in 1852, made him famous overnight. He was appointed professor for German language and literature in Kiel and went to great lengths to have Low German accepted as a literary language. His songs and poems were put to music by many a composer of renown, including one Johannes Brahms (1833–1897), a native of Hamburg.

Journalist and writer Julius Stinde (1841–1905) was from Kirchnüchel near Eutin. He wrote plays for the theatre in Plattdeutsch and also a successful and entertaining series of books on a family in Berlin, the Buchholzens.

There are many more who can be linked to what is now the federal state of Schleswig-Holstein. Some were born here, only to later leave; others chose the north as their new home. Matthias Claudius (1740–1815), for example, was born in Reinfeld, where the Protestant church is named after him; dramatist Friedrich Hebbel (1813–1863) first saw the light of day in Wesselburen which was then under Danish rule.

### Nobel Prize winners

Surely the most famous of them all are the brothers Mann. Their father was senator of economy and finance in Lübeck from 1877 until his death in 1891. Heinrich Mann, the older of the two brothers (1871–1950), rose to fame through his novels *Professor Unrat* (filmed as *Der blaue Engel* or The Blue Angel) and *Der Untertan* (Man of Straw). The younger, Thomas Mann (1875–1955), won the Nobel Prize for Literature in 1929 for *Buddenbrooks*. His novels *Der Zauberberg* (The Magic Mountain), *Joseph und seine Brüder* (Joseph and His Brothers), *Lotte in Weimar* and *Bekenntnisse des Hochstaplers Felix Krull* (Confessions of Felix Krull) were also international hits. Both brothers fled the Nazis to the USA. It was there

that Thomas Mann commented on the devastating air raids on Lübeck in 1942 with regret – but also with understanding. At the time this didn't only earn him popularity; today, however, Lübeck is proud of its honorary citizen.

Not far from Lübeck lives another literary Nobel Prize winner (1999): Günter Grass, born in Danzig in 1927. He has also made a name for himself as a graphic artist, painter and sculptor. His narrative oeuvre includes many titles, the best-known being perhaps *Die Blechtrommel* (The Tin Drum), *Katz und Maus* (Cat and Mouse), *Hundejahre* (Dog Years), *Der Butt* (The Flounder), *Ein weites Feld* (Too Far Afield) and his autobiography *Beim Häuten der Zwiebel* (Peeling the Onion).

In 1902, when the Nobel Prize for Literature was being awarded for just the second time, another Schleswig-Holstein native snapped it up for his *Römische Geschichte* (Roman History): the historian and jurist Theodor Mommsen (1817–1903), born in Garding. Rudolf Ditzen alias Hans Fallada (1893–1947) spent a few turbulent years in Neumünster; the town now awards a literary prize in his name. Siegfried Lenz (*1926) lives close to Rendsburg; many of his stories are set in Schleswig-Holstein. In 2004 the federal state made him a freeman.

James Krüss (1926–1997) was born on Helgoland. He wrote books which became classics, such as *Der Sängerkrieg der Heidehasen* (The Song Contest of the Heather Bunnies) and *Timm Thaler oder Das verkaufte Lachen* (The Boy Who Lost His Laugh). In *Der Leuchtturm auf den Hummerklippen* (The Lighthouse on Lobster Cliffs) and *Mein Urgroßvater und ich* (My Great-Grandfather and I) he writes of life on the island, to which he dedicated the following short rhyme:

*„Irgendwo ins grüne Meer*
*Hat ein Gott mit leichtem Pinsel,*
*Lächelnd, wie von ungefähr,*
*Einen Fleck getupft: Die Insel."*
"Somewhere in the deep, green sea
God took a brush to hand
And with a smile, as if by chance,
He painted there an island."

**Above:**
The Theodor-Storm-Haus in Husum was inhabited by the author from 1866 to 1880. It's now a museum.

**Pictures right**
Dramatist Friedric
Hebbel (1813–1863) wa
born in Wesselburen i
Dithmarschen (top left,

**Left:**
This bust of Theodor Storm, unveiled in 1898, stands in the Schlosspark in Husum.

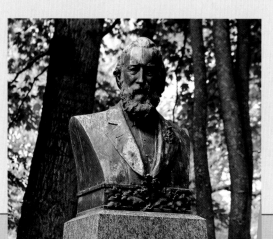

Theodor Mommsen (1817–1903), ancient historian and winner of the Nobel Prize for Literature in 1902, was born in Garding on Eiderstedt (top right).

Thomas Mann (1875–1955) and his older brother Heinrich (1871–1950) came from the Hanseatic town of Lübeck (centre).

Klaus Groth (1819–1899) was the son of a miller from Heide. He was a good friend of Johannes Brahms (1833–1897) whose forefathers were also from Heide (bottom left).

Matthias Claudius (1740–1815) was the son of the pastor of Reinfeld in the district of Stormarn (bottom right).

**Right:**
*Föhr has no less than three Romanesque churches of note. The church of St Laurentii, a 12th-century edifice built of rough stone, marks the edge of the village of Süderende.*

**Below:**
*View of the nave of St Laurentii. In the 1990s Renaissance paintings were uncovered on the ceiling.*

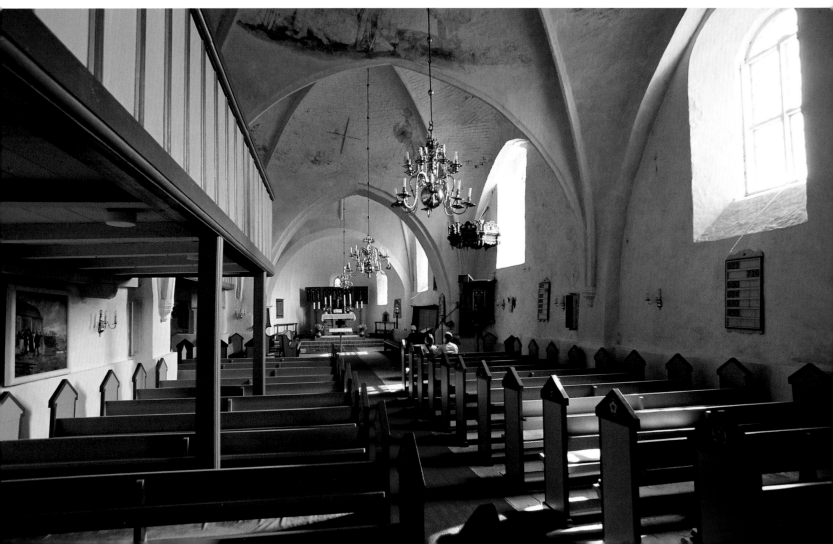

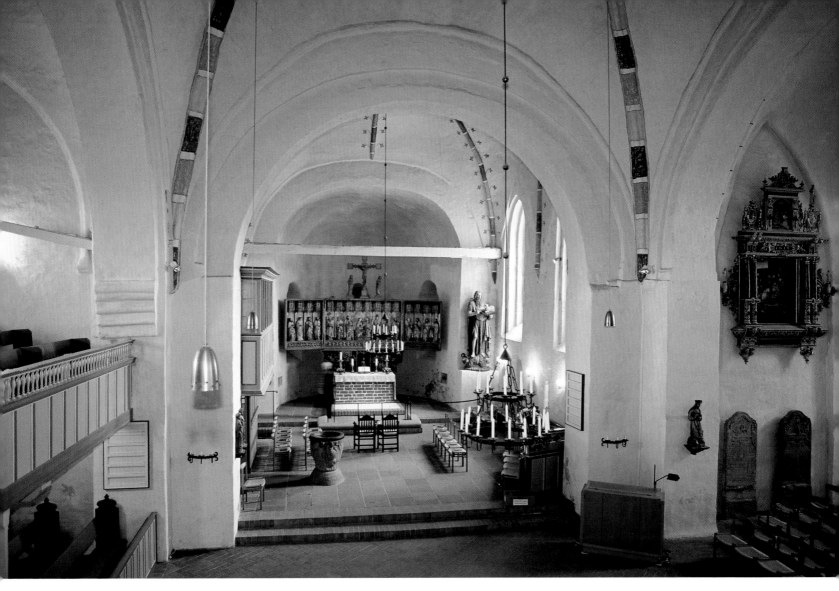

**Above:**
The main attraction of Nieblum is the Romanesque church of St John's, also known as the Frisian Cathedral. It was constructed in the first half of the 13th century.

**Far left:**
Whaler's grave in the cemetery of St Laurentii in Süderende.

**Left:**
Sailor's headstone in the graveyard of the Romanesque church of St Nicolai in Boldixum in Wyk.

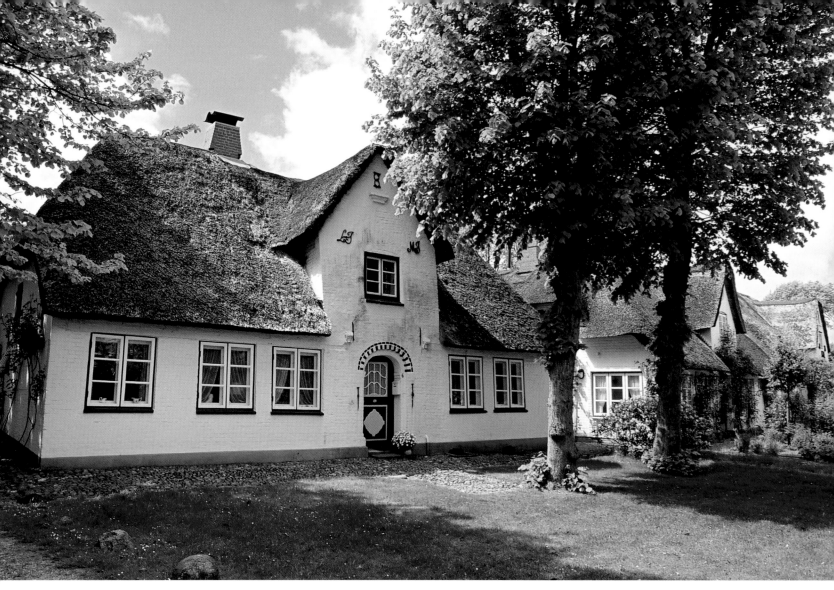

**Left and below:**
*Pretty Frisian houses in Nebel on Amrum. The Öömrang-Hüs (left) is a particularly fine example from 1736. Several of its rooms are open to the public; civil weddings are even held in the Kapitäns-stube. There are also various exhibitions on the history and culture of Amrum which change each year. The name Öömrang refers to the dialect of North Frisia spoken on Amrum.*

**Above:**
The ferry port in Wittdün on Amrum. From here there are connections to Wyk on the island of Föhr and Dagebüll on the mainland, as well as to Schlüttsiel and the Hallig Isles of Langeneß and Hooge.

**Right:**
Travel by car ferry provides a welcome break from driving. The trip from Dagebüll via Föhr to Amrum takes about two hours.

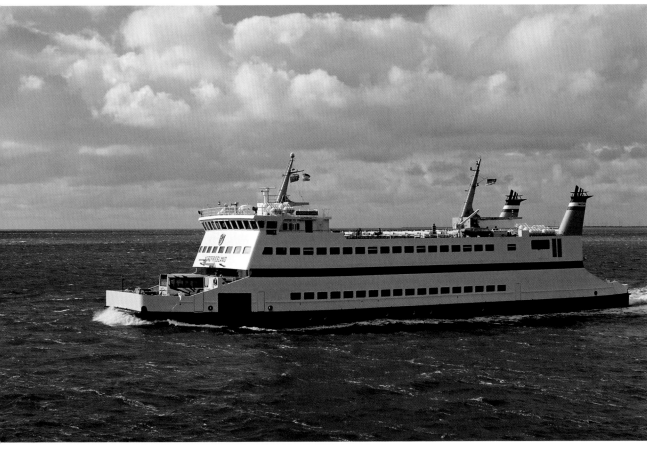

**Left:**
*When travelling to the islands of Föhr and Amrum you can leave your car behind in Dagebüll if you feel so inclined and enjoy getting about using alternative means of transport.*

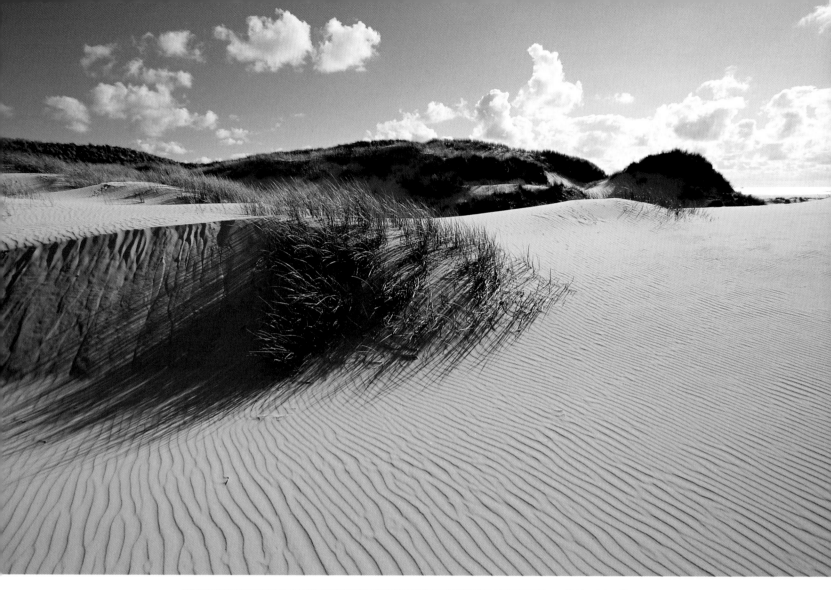

**Above:**
*A ridge of dunes runs the entire length of Amrum, part of which is a nature conservation area providing ideal nesting conditions for many types of seabird.*

**Right:**
*Plank walkway through the dunes near Wittdün, the main port on the island of Amrum. Added to the height of the dunes, the lighthouse which has protected the sandy ridge since 1875 is 63.4 metres (208 feet) high and thus the tallest in Schleswig-Holstein.*

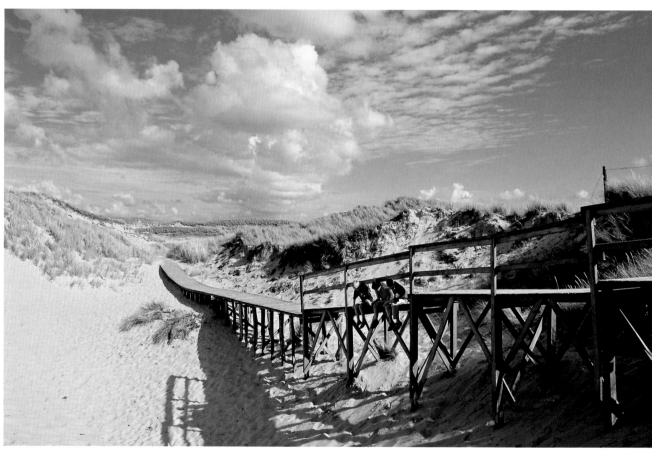

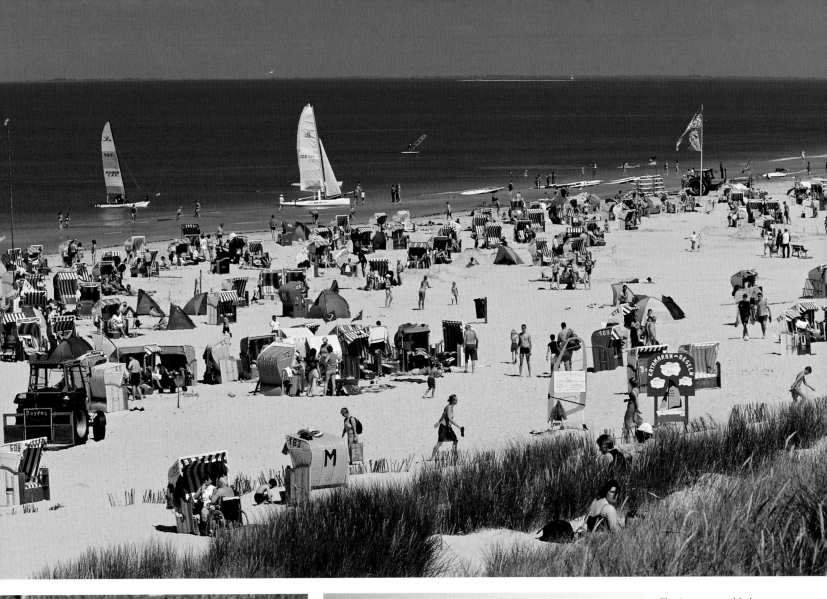

The Amrum seaside is perfect for families. Despite the international mass tourism there are places which have escaped the crowds – and as officially protected areas will also continue to do so.

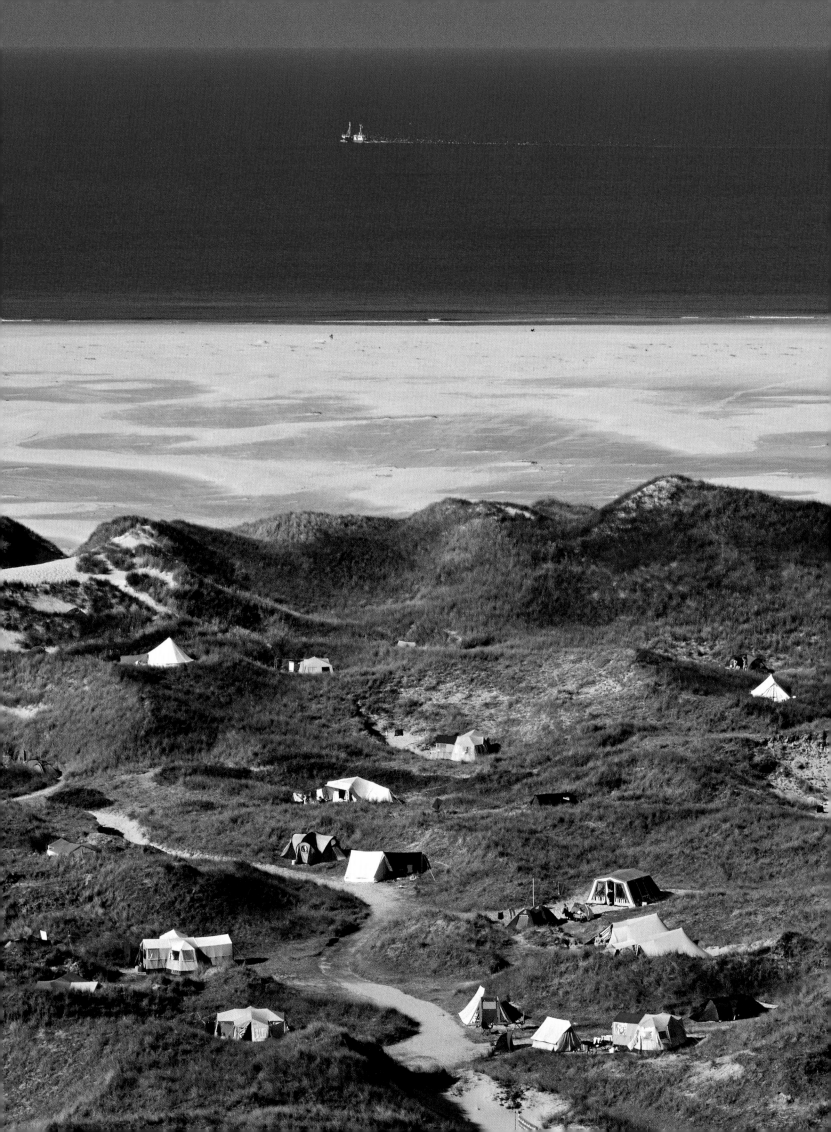

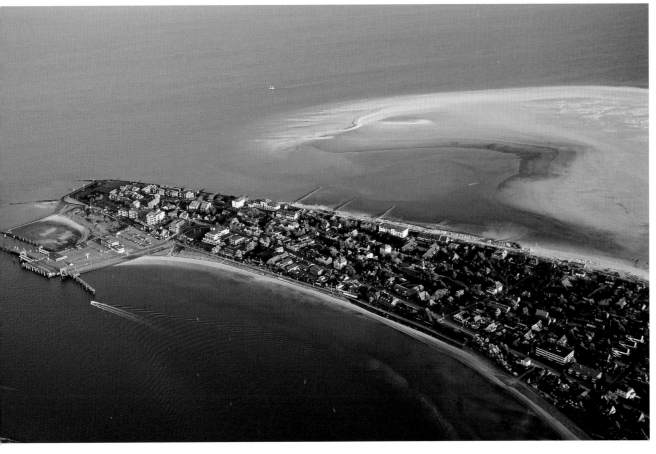

**Left page:**
Campsite in the dunes near the Amrum lighthouse. In the summer season this is open to visitors who can climb the 297 steps to a viewing platform at the top.

View of Wittdün ("white dune") at the southern end of Amrum. The town is still fairly new, having only evolved in the 1890s with the building of the ferry port. Today Wittdün is the gateway to the island.

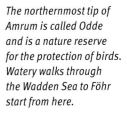

The northernmost tip of Amrum is called Odde and is a nature reserve for the protection of birds. Watery walks through the Wadden Sea to Föhr start from here.

**Above:**
Ferry arriving on Hallig Hooge. The buildings on the Hallig Isles are erected on squat, manmade mounds called Warfte. Some, like Hooge, are surrounded by a summer dyke.

**Right:**
Measuring around 1,000 hectares (2,471 acres) including its foreland, the Hamburger Hallig is joined to the mainland, making it more of a peninsula than an actual island. It has been a nature reserve since 1930.

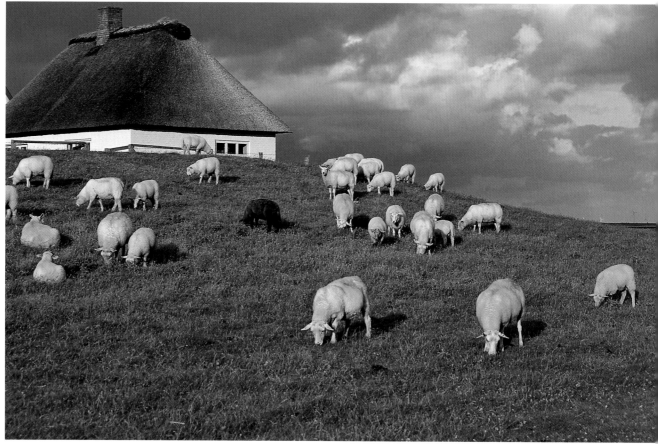

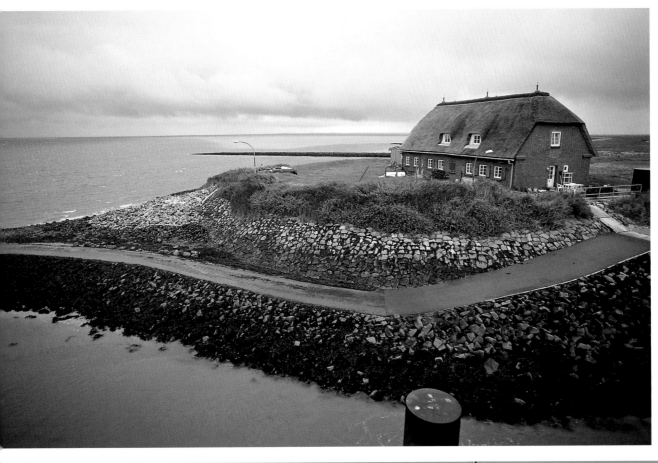

**Left:**
*The Hallig Isle of Langeneß lies southeast of Föhr and is the largest of the Halligs with just over a hundred inhabitants.*

**Below:**
*Transportation by boat at the Ockelützwarft on Hallig Hooge. The island was only plugged into the national electricity grid in 1959 and linked up to the fresh water supply in 1969.*

**Below:**
The Hallig's kindergarten and primary and basic secondary schools are also on Ockelützwarft.

For further, higher-level education the local children have to travel to the mainland.

**Top right:**
Skipper and shipowner Tade Hans Bandix bought this house on Hallig Hooge in 1760. The gabled exten-

sion he added houses the Königspesel, a Frisian parlour from 1776 which still has its original furnishings.

**Centre rig**
Frerk Johannsen fr the Friesenstube muse on Honkenswarf, Ha Langeneß. The house belonged to his family

enturies and is one of the
few family museums in
Schleswig-Holstein. It
hows the historic interior
of a typical Hallig house.

*Bottom right:*
The church of St John's
is on the aptly named
Kirchwarft or church
mound on Hallig Hooge

and is smaller than the
neighbouring vicarage!
Some of the services
are held entirely in Low
German or Plattdeutsch.

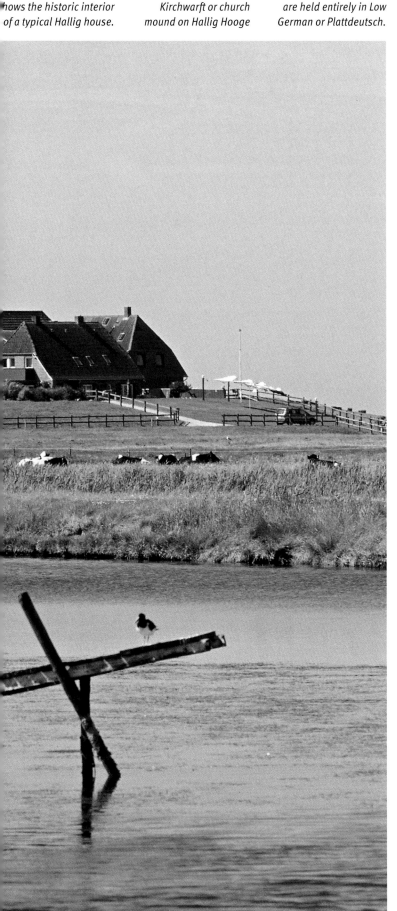

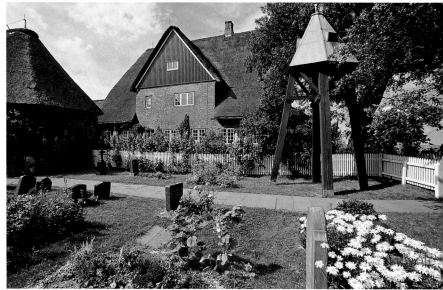

89

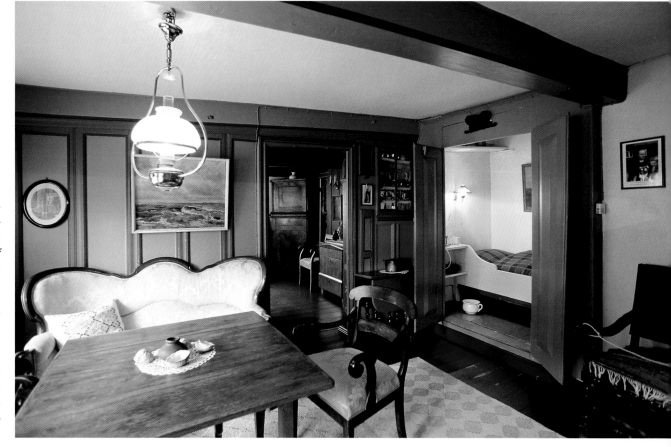

**Right:**
View of the parlour in the Haus Gertsen museum on Ketelswarft, the largest of the manmade mounds on Hallig Langeneß.

**Below:**
With a population numbering just 13 at present, Hallig Gröde is the fourth-smallest community in Germany. The church from 1779 is a listed building and boasts a Renaissance altar from 1592.

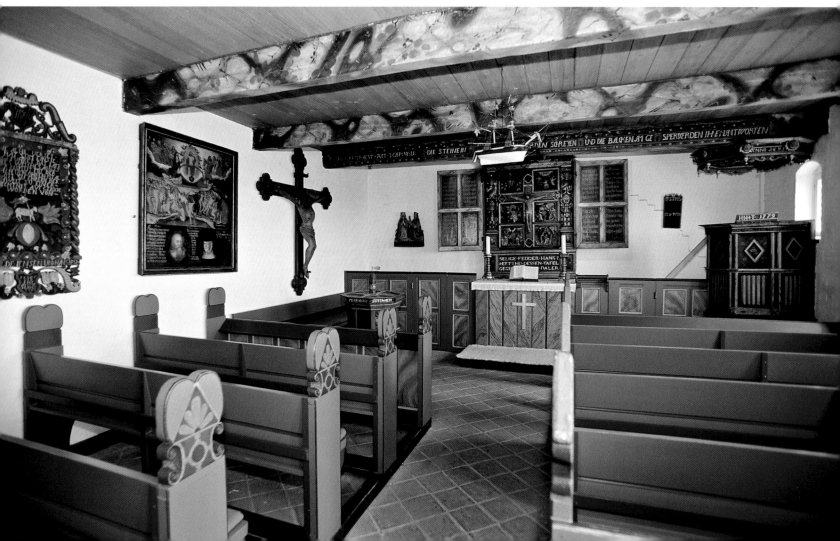

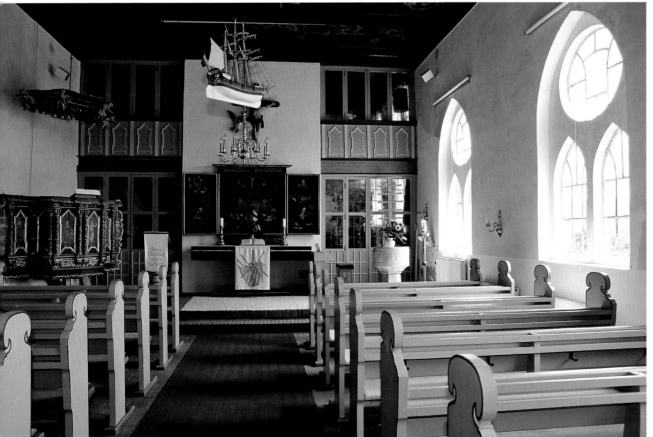

**Above:**
The sumptuously furbished Königspesel on Hallig Hooge includes the bed that Frederick VI, the king of Denmark, spent a night in when caught unawares by a storm tide on a visit here in 1825.

**Left:**
The church on Hallig Langeneß was erected on the foundations of an older building in 1894. Its interior was redesigned in 1975.

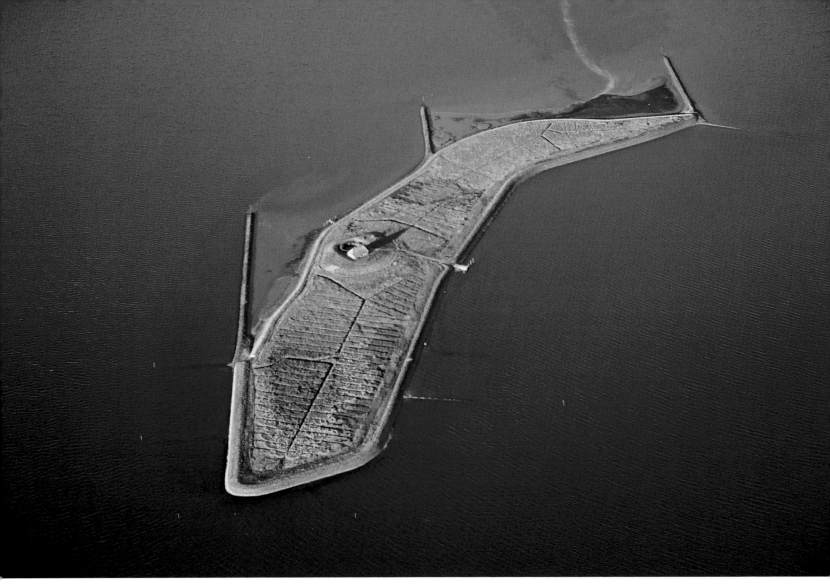

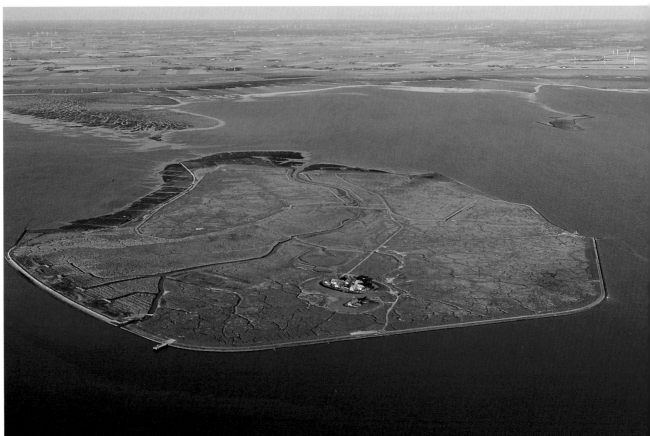

**Above:**
At 7.4 hectares (18 acres) Habel is the smallest Hallig Isle in the North Frisian Wattenmeer. One of its Warfte has a bird protection centre monitoring the many seabirds that nest here. Public access is thus denied.

**Right:**
Hallig Gröde seen from the west with the mainland in the background. Despite its summer dyke the Hallig is flooded about a hundred times a year.

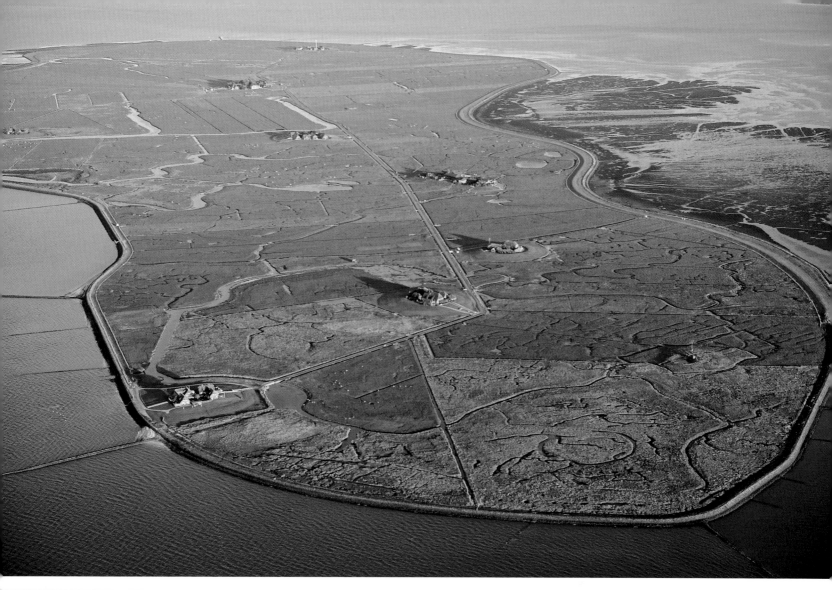

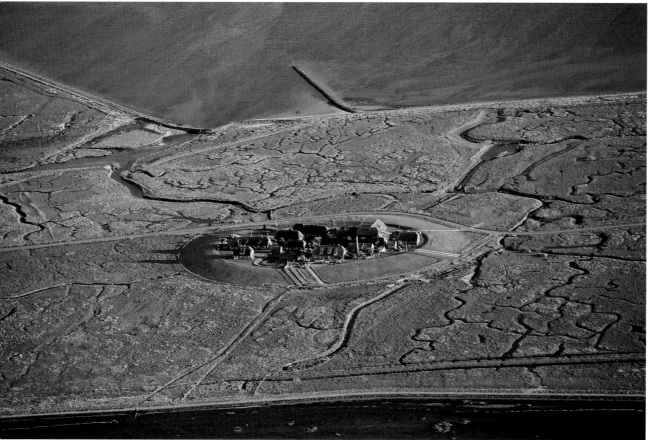

**Above:**
*Hallig Hooge seen from the air. The effects of climatic change can also been seen in the Hallig Isles: there are more floods than ever before.*

**Left:**
*On average Hallig Langeneß is just one kilometre wide. Kirchwarft houses not just the church but also the vicarage and the school.*

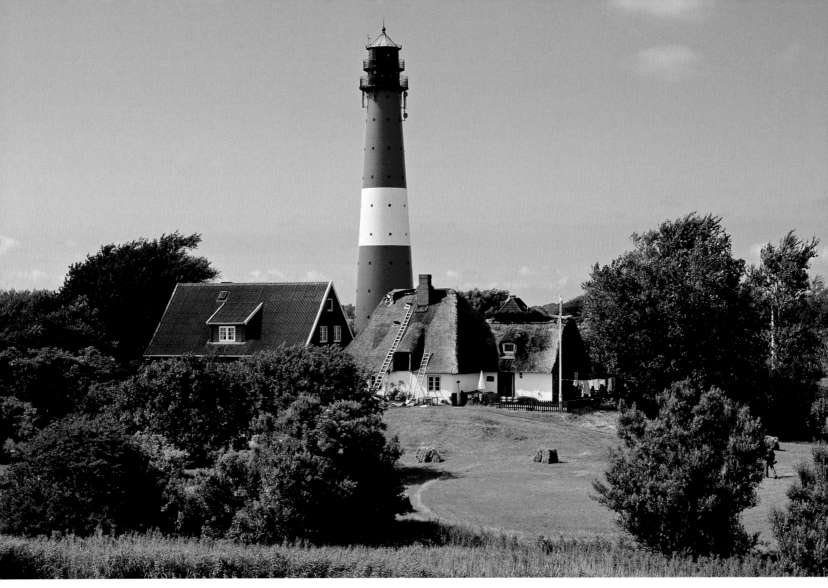

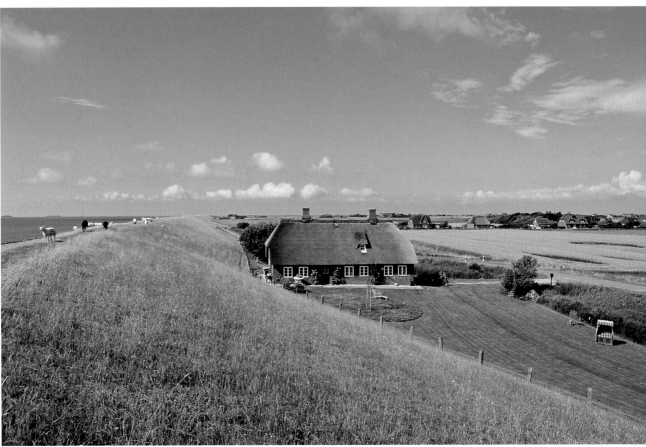

**Above:**
On the island of Pellworm. At 37.4 square kilometres (14 square miles) it's the third largest of the North Frisian Islands. The tall lighthouse from 1906 has a registry office at the top.

**Right:**
Holiday cottage on Pellworm. The island has about 2,000 beds and 200,000 bookings a year. After agriculture tourism is its biggest economic factor.

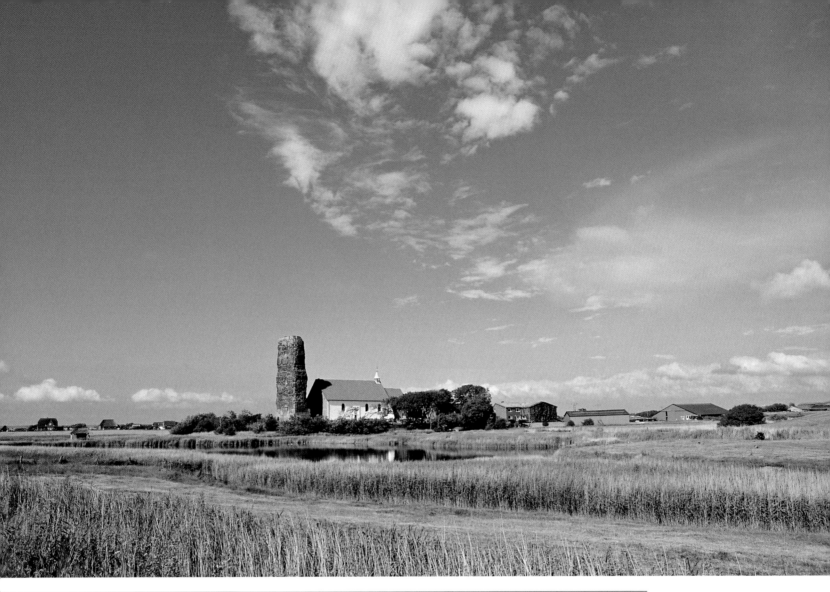

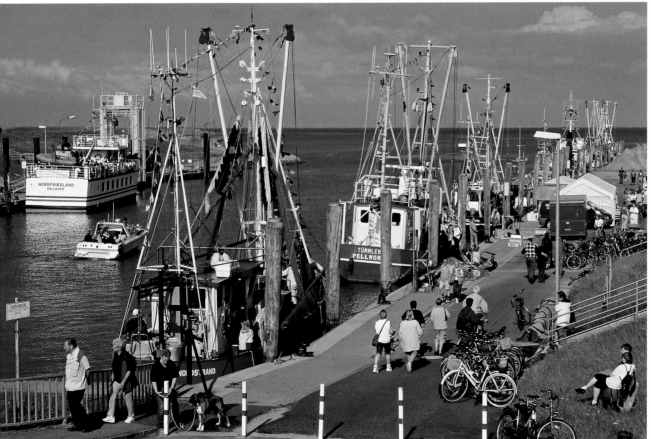

**Above:**
*Pellworm's local landmark is the impressive ruined steeple of the 11th-century Salvatorkirche. The belfry fell down in 1611 as the soft mudflats weren't strong enough to bear its weight. The church contains one of the few organs built by Arp Schnitger (1648–1719) in 1711.*

**Left:**
*Shrimp cutter in the harbour at Ütermarker-koogsmitteldeich on Pellworm. The island is an average of one metre (three feet) below sea level and is thus protected by a dyke eight metres (26 feet) high and 28 kilometres (17 miles) long.*

**Below:**
*The yachting harbour in Süderhafen on Nord-strand. Dykes and silting have turned the former island into a peninsula.*

**Top right:**
In Fuhlehörn on Nordstrand you can travel through the Watt on a horse and cart. The drive to Hallig Südfall takes about an hour.

**Centre right:**
The church of St Vinzenz von Odenbüll on Nordstrand goes back to the 13th century but was refurbished during the 19th.

**Bottom right:**
The ferry port of Strucklahnungshörn on Nordstrand. There are regular ferry connections from here to the neighbouring island of Pellworm.

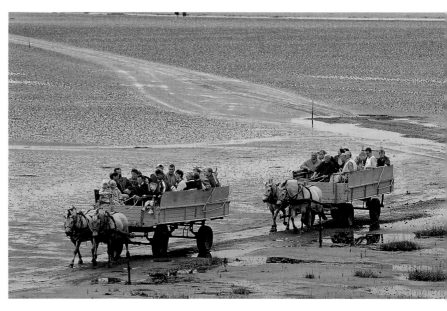

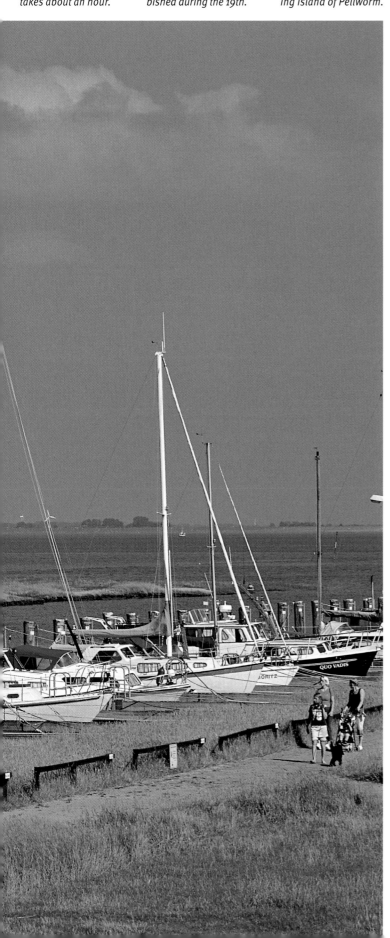

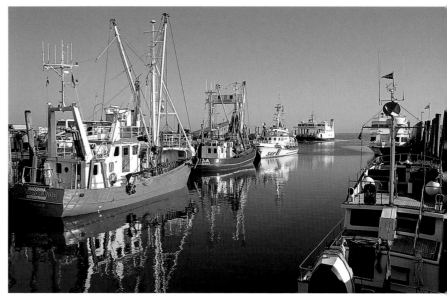

97

# A DRAMATIC HISTORY: HELGOLAND

"Welkoam iip Lunn!" (welcome to the country) is the greeting extended to guests to Helgoland in the local lingo. 62 kilometres (38 miles) northwest of the Elbe estuary, a plateau of red sandstone, Muschelkalk and chalk rises up to 50 metres (164 feet) above sea level in the middle of the Deutsche Bucht. Helgoland. Originally part of the mainland, it was cut off about 10,000 years ago when the level of the North Sea rose dramatically.

Archaeological finds – barrows in the Oberland on Helgoland – indicate that the area was inhabited in the New Stone Age. About 5,000 years ago, intrepid Bronze Age seafarers set off for Helgoland in their dug-out canoes in search of red flint, a coveted raw material used to make weapons and tools. In the Middle Ages Helgoland, then about four times its present size, was settled by the Frisians. The local consensus is that the name of the island means "Holy Island" and that it was once a site of some religious importance. It could, however, also be interpreted as "rising above", with the same root as the word "Hallig" as in the Hallig Isles.

### Lange Anna

The island changed hands several times, with the Danes seizing control in 1714. The sea also laid hand on the island, constantly tearing away at the cliffs – as did the inhabitants, who shipped Muschelkalk and gypsum off to the mainland as building materials. On New Year's Eve 1720/21 a storm tide washed away the section of land linking the block of red sandstone and what is now Düne. Since then Helgoland has been two: the main island and the smaller seaside island of Düne. Helgoland's uncontested local landmark is an elongated, solitary needle of rock called Lange Anna.

In 1807 British troops occupied the island and turned it into an English colony. In 1826 a seaside resort was founded. Writers and intellectuals discovered Helgoland as a holiday destination. Heinrich Heine (1797–1856) came here looking for a place of respite and found that "the sea smells of cake". It was on Helgoland that Heinrich Hoffmann von Fallersleben (1798–1874) wrote *Das Lied der Deutschen* or *The Song of the Germans* which was later used as the lyrics of the German national anthem. In the Helgoland-Zanzibar Treaty of 1890 territorial claims in the African colonies were settled between the German Empire and Great Britain. In it, Germany agreed to curtail its interests in East and Southwest Africa; in return, Britain gave Helgoland to Germany. Kaiser Wilhelm II promptly had the island turned into a naval base.

### The land that went to hell

The National Socialists extended the military base and declared Helgoland a "marine fortress". On April 18, 1945, the Allies dropped 7,000 bombs on the island in less than two hours. The island became uninhabitable and was evacuated, with some of the population making a new home for themselves on Sylt. Exactly two years after the air raid the British blew up the military bunkers in the biggest nonnuclear explosion to date. A sixth of the island fell into the sea. Up until 1952 it remained a military no-go area and was used for bomb target practice by the Royal Air Force. The pilots gave it a new name to match its sorry existence: Hell-go-land.

The people of Helgoland living in exile wanted to save their island and appealed to the United Nations, the pope, the British House of Commons and the German government. At Christmas 1950 two students from Heidelberg squatted on the island and raised the flags of Europe, Germany and Helgoland. Their autonomous demonstration sparked off a new movement to repopulate the island. On March 1, 1952, Helgoland was returned to the Federal Republic of Germany. 170,000 metric tons of fighting power had to be removed. Since then March 1 has been celebrated as the island's day of resurrection with great ceremony and a grand church service. In 1993 the two demonstrators

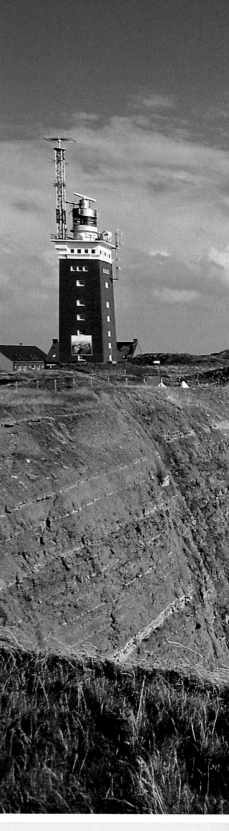

*Far left:*
*The Helgoland Oberland in c. 1929/30, photographed from the lighthouse.*

*Left:*
*Helgoland in March 195? after the British had give it back to Germany. The island had been totally annihilated.*

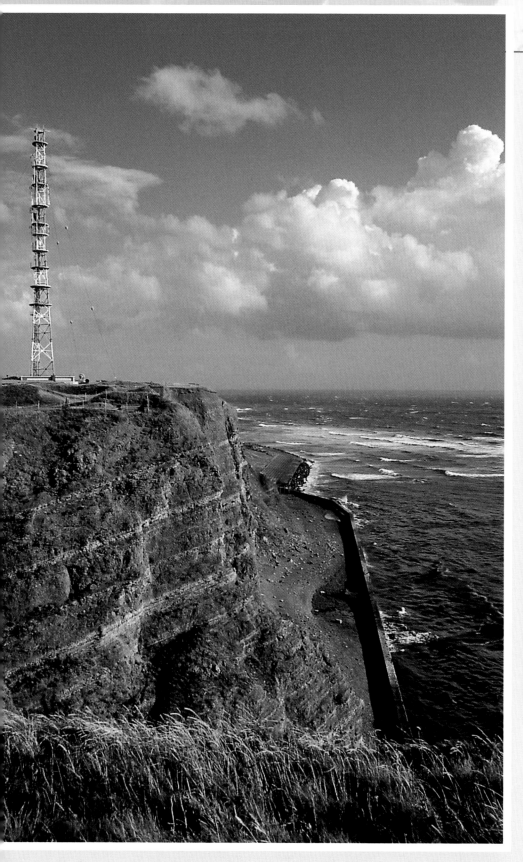

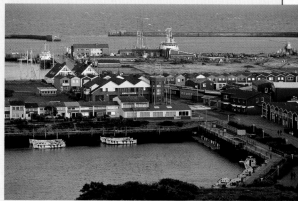

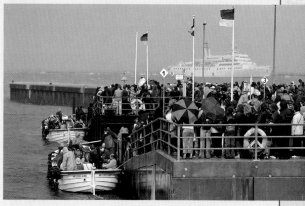

were awarded the Bundesverdienstkreuz, Germany's prestigious order of merit, for their non-violent act of protest.

The wounds have long healed, even if there are still lots of bomb craters and ruined concrete bunkers scattered about the island. Its 1,300 inhabitants now live off tourism and spa guests. As the island is not actually part of the EU for tax purposes it's also paradise for shoppers, with no customs duties or VAT levied on goods. 500,000 day trippers visit each year, with 45,000 nights booked annually. Helgoland is a state-approved seaside health resort. There are few places which are as quiet and where the sea and air are as clean. And the night sky is truly breathtaking, miles away from the streetlight smog of Europe's suburban conurbations.

**ove:**
*ghthouse and radio mast*
*the southwest edge of*
*Helgoland Oberland.*
*e lighthouse was*
*ginally an anti-aircraft*
*tion built in 1941.*

**Top right:**
*The inland harbour with*
*its customs office and the*
*little houses known as*
*Hummerbuden or lobster*
*huts where local fishermen*
*used to live and work.*

**Centre right:**
*The Hummerbuden are*
*now used for a number of*
*different purposes, from*
*registry office to snack bar*
*to souvenir shop. And they*
*also sell lobster!*

**Right below:**
*Disembarking in bad*
*weather on Helgoland.*
*Here, too, the rule applies*
*that there's no bad weather,*
*just inappropriate clothing!*

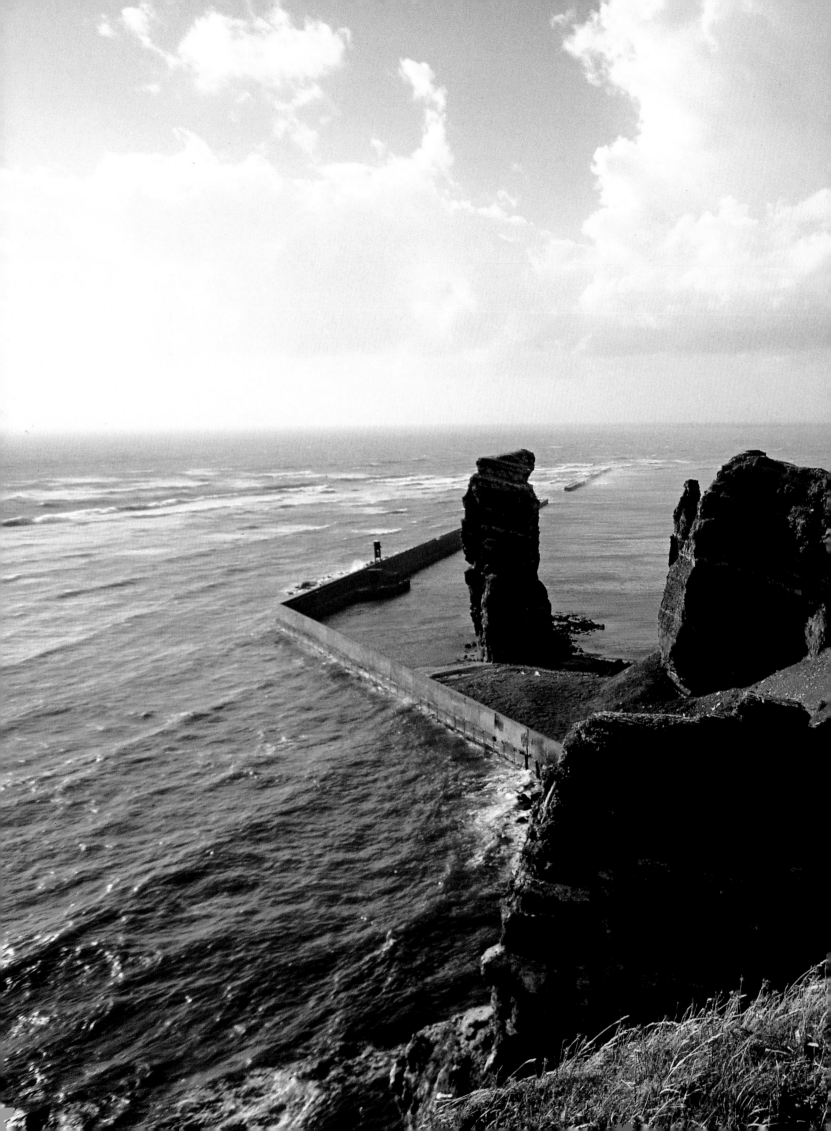

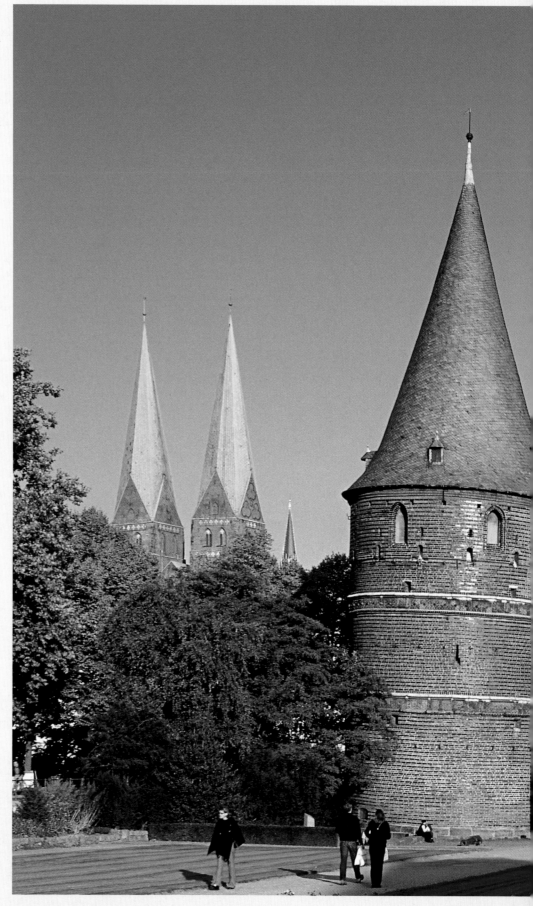

**Page 100/101:**
*Lange Anna or long Anna, Helgoland's local landmark in the far north-west of the island. Anna is a freestanding needle of red sandstone measuring 47 metres (154 feet) in height and just 18 square metres (194 square feet) in area. Its corrosion cannot be stopped; experts believe that the top two thirds will soon break off.*

**Right:**
*The distinguishing feature of the Hanseatic town of Lübeck is the Holstentor or Holstein Gate. In the background the steeples of the Marienkirche rise tall, with the tower of the Petrikirche to the right and the old salt stores in front of this.*

With its lush green pastures, sparkling lakes and expanses of forest, the southernmost district of Schleswig-Holstein, or what was once the duchy of Lauenburg, is perfect hiking and cycling territory. The 800-year-old town of Lauenburg on the Elbe was largely spared the bombs of the Second World War and its historic centre is thus worth visiting. Halfway between Lauenburg and Lübeck is the town of Till Eulenspiegel, Mölln, with its Gothic town hall from 1373. The surrounding Lauenburgische Seen nature reserve provides it with an idyllic setting. The largest of the reserve's lakes is the Ratzeburger See which with the Küchensee encircles the "island town" of Ratzeburg.

The largest city in surface area in Schleswig-Holstein is Lübeck. Its medieval nucleus has been made a UNESCO World Heritage Site, its most famous feature being the late Gothic Holstentor. The Holsteinische Schweiz or Holstein Switzerland gently undulates between Kiel and Lübeck, its hills and lakes bequeathed to it by the last glacial period. The highest peak in Schleswig-Holstein rises just beyond Schönwalde: the Bungsberg, 168 metres (551 feet) above sea level.

Fehmarn, at 185 square kilometres (71 square miles) the third-largest island in Germany after Rügen and Usedom, has been joined to the mainland by the bridge over the Fehmarn Sound since 1963. Across it runs the imaginary 'line of migration' which links Hamburg and Copenhagen; most holidaymakers simply dash across Fehmarn on their way to Puttgarden and the Denmark ferry. Many then miss out on the island's capital, the attractive town of Burg.

If you love the sea, you'll feel perfectly at home in the resorts dotted about the bays of Lübeck and Kiel, these being Travemünde, Timmendorfer Strand, Scharbeutz, Grömitz, Laboe and Damp. Right on the border with Denmark there's Flensburg, famous in Germany for being the seat of the national vehicle administration centre where traffic offences are duly recorded .

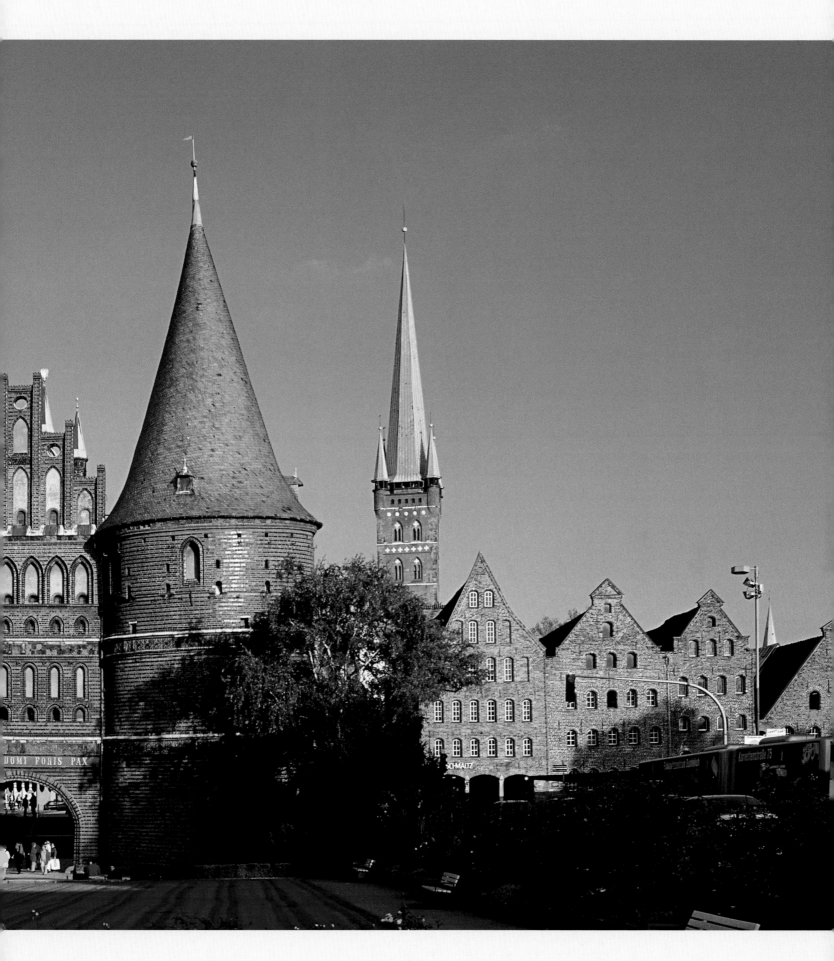

*Right:*
The Buddenbrookhaus (Heinrich-und-Thomas-Mann-Zentrum) next to the church of St Mary's in Lübeck. The building is from 1758; Heinrich and Thomas Mann's grandfather bought it in 1842.

*Far right:*
On Koberg is the meeting place of the fishermen's society from 1535 which now houses a restaurant.

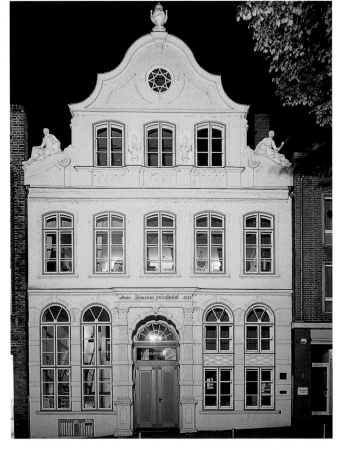

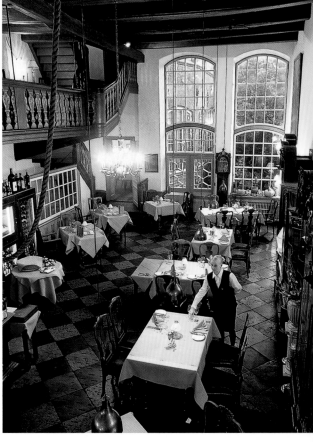

*Far right:*
Mengstrasse is in the old merchants' quarter of Lübeck between the port on the Trave and the Rathaus or town hall. A few of its typical gabled houses still grace the lower quarter.

*Right:*
The private TheaterFigurenMuseum in Lübeck is in the old part of town not far from the Holstentor in the tiny street of Kolk. It has around one thousand hand puppets, marionettes, stick and finger puppets, shadow play figures and everything else no good puppet theatre should be without.

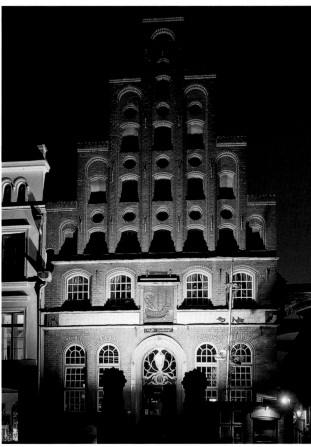

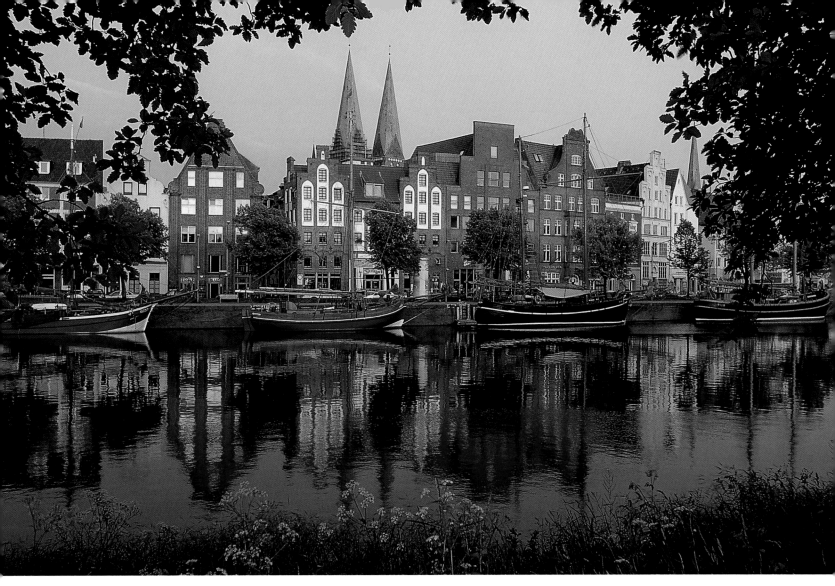

**Above:**
On the Upper Trave River.
The medieval part of Lübeck
is a UNESCO World Heritage
Site which clings to an
island between the rivers
of Trave and Wakenitz. For
a time the Queen of the
Hanseatic League was the
most important trading
post in northern Europe.

**Left:**
The historic salt stores
on the River Trave. This
is where the white gold
of the Middle Ages was
stored. Over three thou-
sand ships were unloaded
here each year.

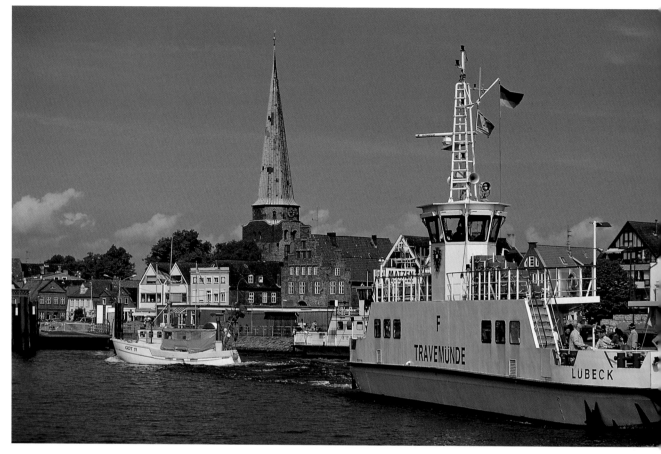

Lübeck-Travemünde is about 20 kilometres (12 miles) from the centre of Lübeck at the point where the Trave flows into the Bay of Lübeck. Here we can see the old town with the Lorenzkirche.

The harbour of Neustadt in Holstein, 32 kilometres (20 miles) north of Lübeck on the Bay of Lübeck. The distinctive old warehouses tell of its former great significance as a port, founded by Count Adolf IV of Holstein in 1244.

**Right page:**
Travemünde Harbour is home to the four-masted barque and museum ship the Passat, which sailed out of the docks of Blohm + Voss in 1911 as one of the legendary Flying P-Liners run by the German shipping company F Laeisz. The Passat was made a protected historical monument in 1978.

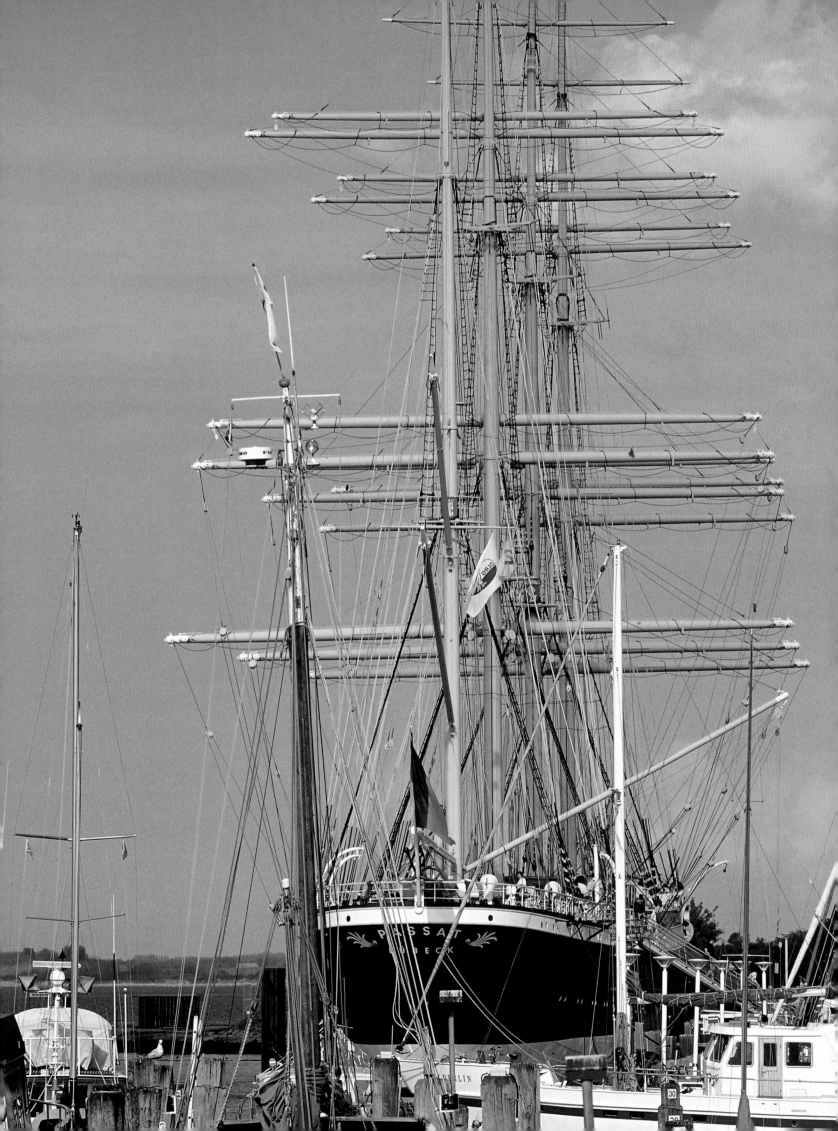

**Right:**
*The quiet little fishing village of Haffkrug, a seaside spa since 1813, lies nestled on the west of the Bay of Lübeck. Various boat trips set off from the pier.*

**Far right:**
*The Baltic goes Brazil! Two suburbs in the Baltic seaside resort of Schönberg in the Plön district have exotic names: Brasilien (Brazil) and Kalifornien (California).*

**Right:**
*The beach in Travemünde. Travemünde is one of the biggest German ferry ports for connections to Scandinavia, almost all ports in Finland and the Baltic.*

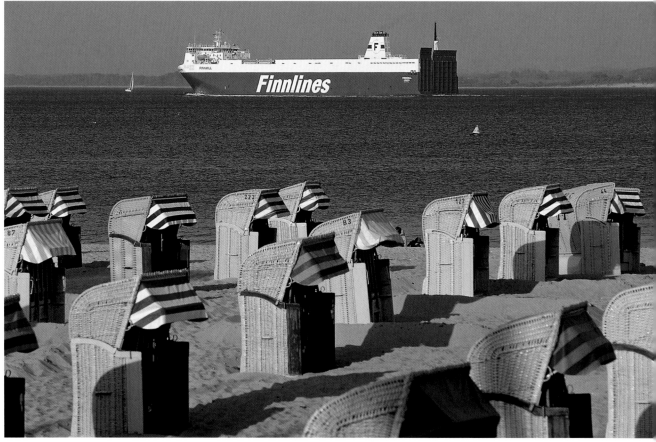

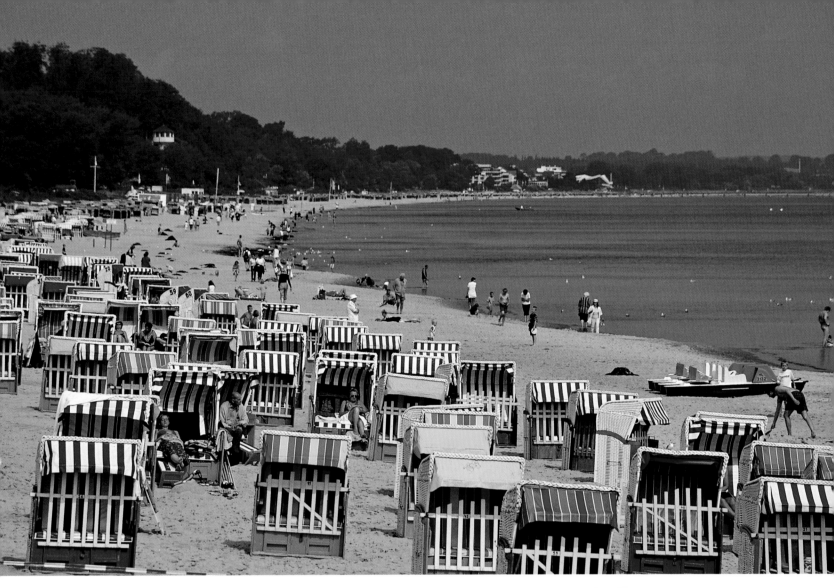

**Above:**
The chic resort of Timmendorfer Strand on the Baltic coast is about 15 kilometres (9 miles) from Lübeck. The historic centre is dotted with Gründerzeit guest houses and villas from the 19th century.

**Small photos, left:**
On the beach in Sierksdorf. The town was once a fishing village popular with artists. Expressionist painter Karl Schmidt-Rottluff spent his summers here between 1951 and 1973. The attractions of Sierksdorf include the Hansa-Park on the seafront which is a big hit with families.

**Above:**
*Puttgarden in the north of the island of Fehmarn is a major stop on the route from Hamburg to Copenhagen. The port's days are numbered, however; once the permanent crossing over the Fehmarn Belt is finished, it will be closed.*

**Right:**
*Avenue near Burg on Fehmarn, the main suburb of the town of Fehmarn. Up until 2003 the little town on the third-largest island in Germany was autonomous.*

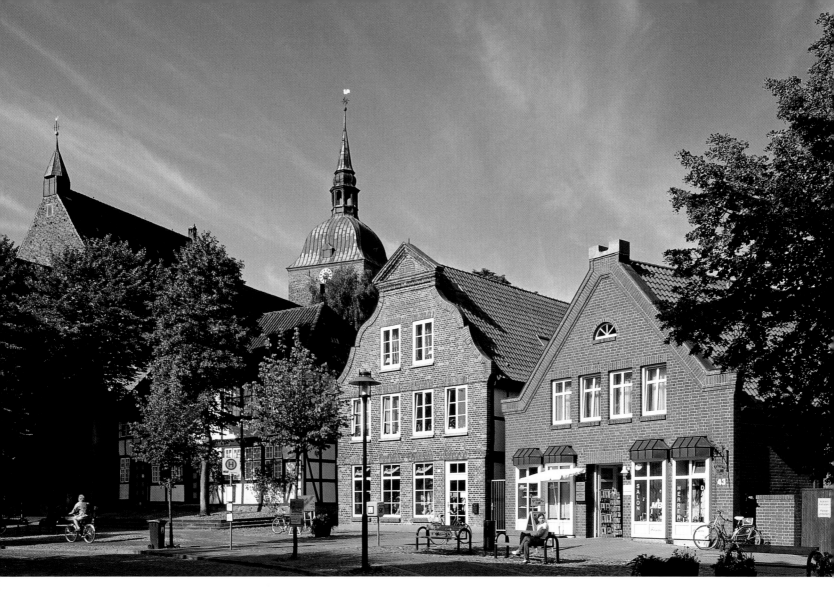

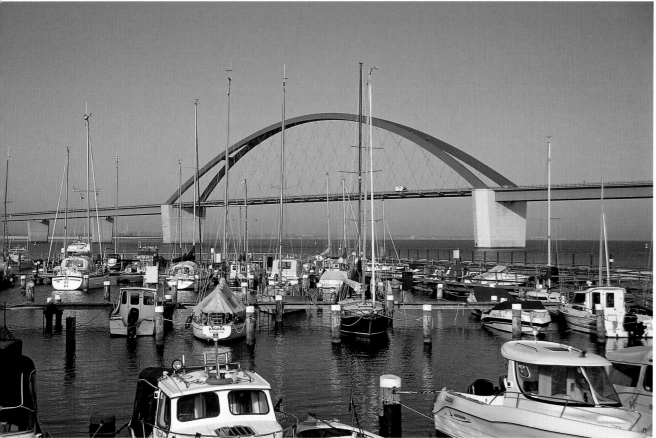

**Above:**
Burg on Fehmarn,
dwarfed by the steeple of
the late medieval church of
St Nikolai which was built
between 1230 and 1250. In
the foreground is the area
known as the Stiller Winkel
with the museum of local
history.

**Left:**
The long rail and road
bridge across the Fehmarn
Sound links the island of
Fehmarn with the mainland
near Großenbrode. It was
opened on April 30, 1963.

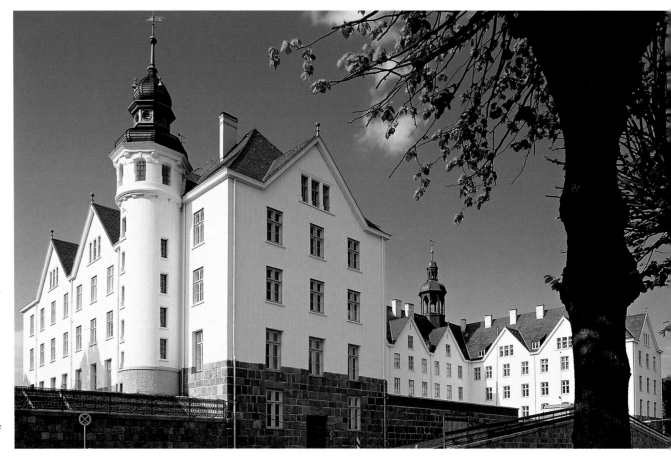

*Right:*
The landmark of Plön is its palace built in the 17th century. From 1840 onwards it served as the official summer residence of the king of Denmark, Christian VIII. It was taken over by a firm of opticians in 2002 and elaborately restored. Parts of it are now open to the public.

*Below:*
On the Großer Plöner See close to the idyllic health resort of Dersau which is about seven kilometres (four miles) southwest of the town of Plön.

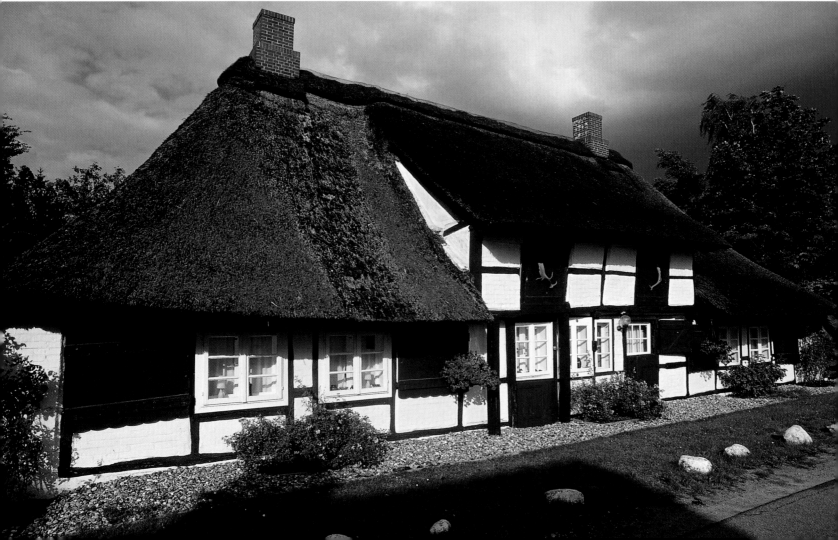

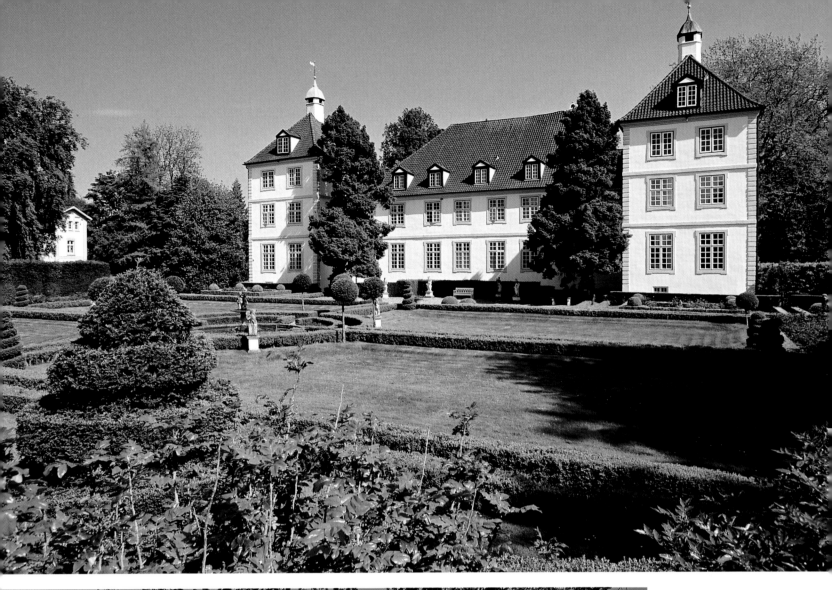

**Above:**
Gut Panker in the Plön
district lies between the
Selenter See and the Baltic.
The present manor house
was erected in c. 1800.
It's in private ownership
and inhabited and thus
not open to the public.

**Left:**
Gut Panker also breeds
Trakehner riding horses.
The farm started out with
twenty mares which were
rescued from East Prussia.

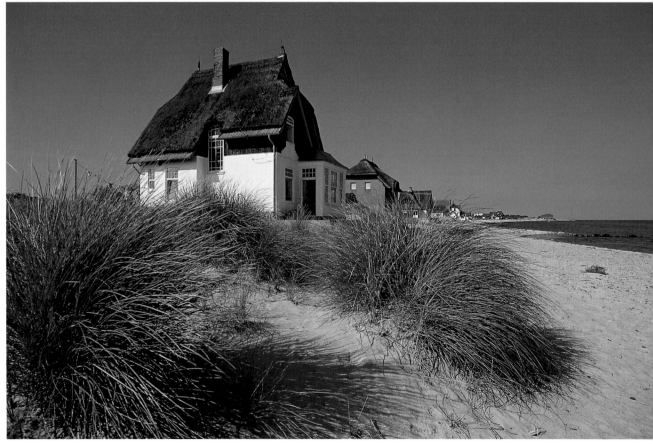

**Above:**
*View from Heiligenhafen of the Graswarder Promontory. Originally an island, the sand washed up over the centuries gradually fused Graswarder with the then peninsula of Steinwarder.*

**Right:**
*Together Graswarder and Steinwarder make up a nature reserve 230 hectares (568 acres) in size. Pretty houses line the sandy beach.*

**Left:**
*Country idyll near Lütjenburg in the district of Plön. In the aftermath of the Second World War the number of inhabitants in the area practically doubled as many people from Kiel and displaced persons were rehoused here.*

**Below:**
*Schloss Eutin is the cultural epicentre of the town of Eutin. Once a medieval castle, it was gradually turned into a palace in the course of several centuries. Guided tours provide access to several rooms containing their original furnishings from the late baroque to the neoclassical periods.*

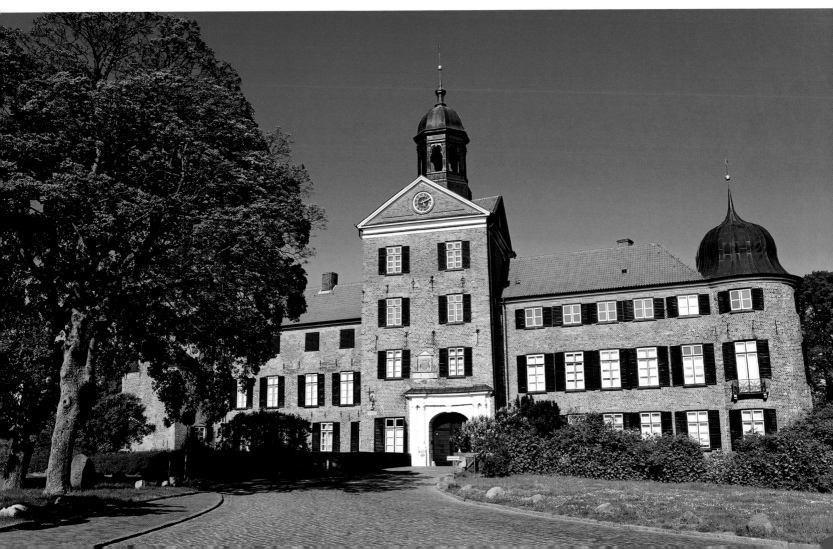

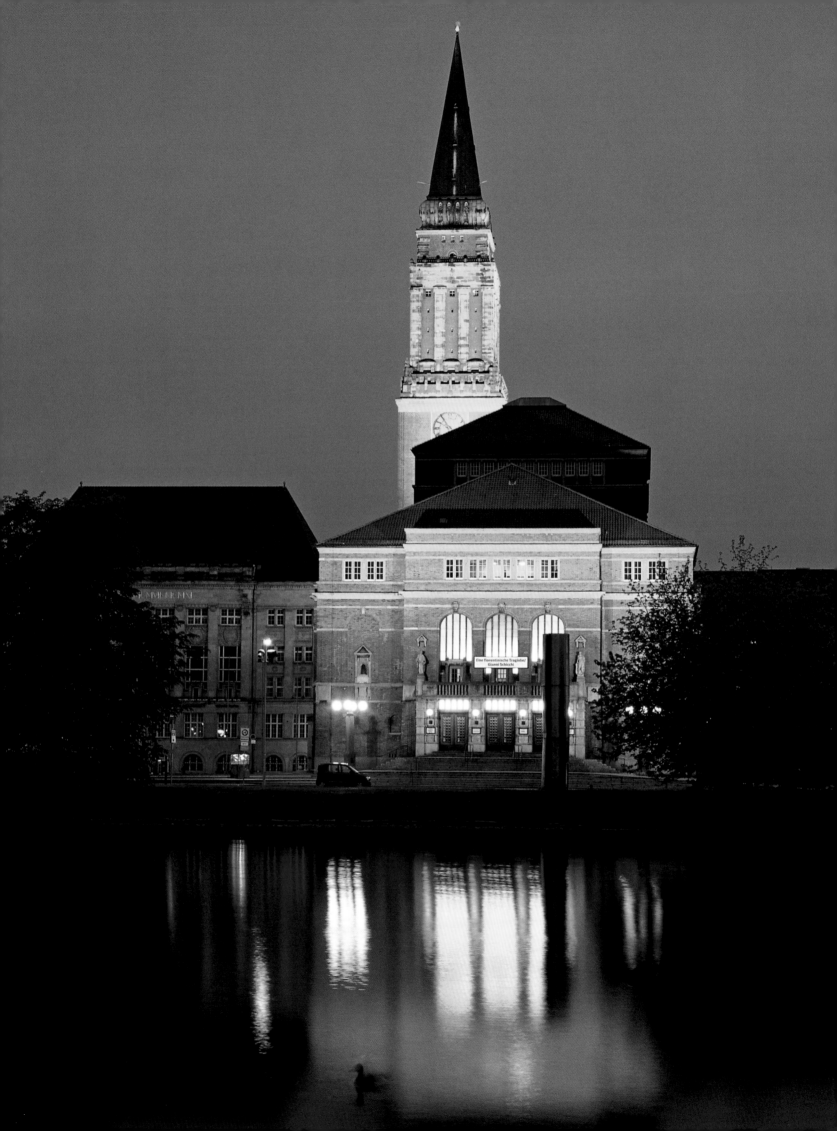

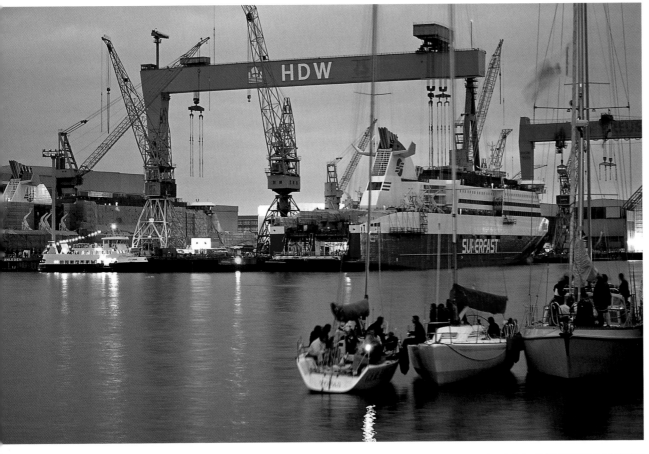

**Left page:**
*The distinctive town hall tower with the opera house in front of it is the landmark of the federal capital of Kiel. With a population of approximately 237,000, Kiel is the largest city in the federal state of Schleswig-Holstein.*

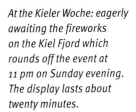

*At the Kieler Woche: eagerly awaiting the fireworks on the Kiel Fjord which rounds off the event at 11 pm on Sunday evening. The display lasts about twenty minutes.*

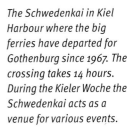

*The Schwedenkai in Kiel Harbour where the big ferries have departed for Gothenburg since 1967. The crossing takes 14 hours. During the Kieler Woche the Schwedenkai acts as a venue for various events.*

# THE KIELER WOCHE: THE BIGGEST SAILING EVENT IN THE WORLD

Kiel has borne "the sign of modesty since its very beginnings", author Ernst von Salomon (1902–1972) once wrote of his native city. The state capital of Schleswig-Holstein goes back to a settlement founded by Count Adolf IV of Holstein between 1233 and 1242 and morphed into major centre of finance during the late Middle Ages. The opening of the university in 1665 granted the city further material and intellectual wealth. In 1844 the railway line to Altona linked Kiel to the Elbe and the North Sea. In 1871 the city became a military harbour town servicing the newly founded German Empire.

In 1918 history was written in Kiel. In the Sailors' Revolt at the end of the First World War marine soldiers demanded that those war-weary comrades be freed who had refused to stage a 'final battle' against the Royal Navy. This resulted in the November Revolution which brought down the German monarchy. During the Second World War Kiel's role as a wartime harbour and site of the armaments industry was to be its doom; Allied air raids destroyed over 80 percent of the city. As in other many other places rebuilding was swift, lending the centre of town an appearance which is prosaic rather than poetic.

Modesty is not called for, however, when the Kieler Woche is on. The jamboree starts on the Saturday before the last full week in June and lasts nine days. It's the biggest sailing event in the world; 5,000 sailors handling 2,000 boats from 50 nations take part in the competitions, with 3.5 million guests from over 70 countries of the world coming to watch the huge summer sailing festival on the firth.

## A long tradition

In 2007 the Kieler Woche celebrated its 125th anniversary. On July 23, 1882, the starting pistol was fired on the western shores of the firth for a one-day sailing regatta in which twenty yachts took part. Thousands of spectators turned up; the water was so full of boats crammed with onlookers that the participants had to more or less fight their way through to the race. Right from the outset members of the imperial family were present, among them navy officer Prince Henry of Prussia, after whom the navy blue peaked cap popular on the coast is still named (*Prinz-Heinrich-Mütze*). Henry took part for the first time in 1885 and in 1893 was joined by his brother, William – otherwise known as Kaiser Bill or Wilhelm II. In 1892 100 boats thronged the starting line, including several from other countries in Europe and from the USA.

In 1894 the local newspaper, the *Kieler Zeitung*, first used the term "Kieler Woche" or Kiel week. Even then the regatta went hand in hand with a full programme of social activities. Today about 1,500 events complement the actual sailing, including open-air concerts of classical music, folklore and pop, ballet, drama and cabaret. There's an international market inviting visitors to undertake a cultural and culinary journey round the world; there are soap box races and other fun things for kids and even scholarly symposia.

The most important aspect of the Kieler Woche, however, is that which makes Kiel the sailing city of the world, as it likes to call itself: sailing, from the regatta for children and teenagers in optimist dinghies to the race for high-tech yachts. For many, the absolute highlight of the week is the windjammer parade on the second Saturday, when about one hundred tall ships and traditional craft from many different nations peruse the inner firth before an enthusiastic audience.

The parade is often fronted by the Gorch Fock, the German navy's training vessel. It's named after the writer Johann Wilhelm Kinau (1880–1916), whose pseudonym was Gorch Fock, Gorch being a corruption of George. Built at the Blohm+Voss shipyard in Hamburg and commissioned in 1958, the steel barque is 89.4 metres (293 feet) long and 12 metres (39 feet) wide. With a sail area of 2,037 square metres (21,926 square feet) it has a maximum speed of 18.2 knots (ca. 34 kmh/21 mph). Women joined the crew of 289 in 1989. An engraving of the proud ship was printed on the back of the ten deutschmark note in circulation between 1963 and 1989.

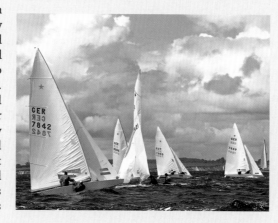

**Left:**
The participants in the sailing regattas come from around 50 different nations, from Argentina to White Russia.

**Above:**
From 1906 to 2005 the start of the Kieler Woche was marked by the Aal-regatta or eel regatta wh. went back to the traditio of giving each contestan smoked eel on their arri in Eckernförde.

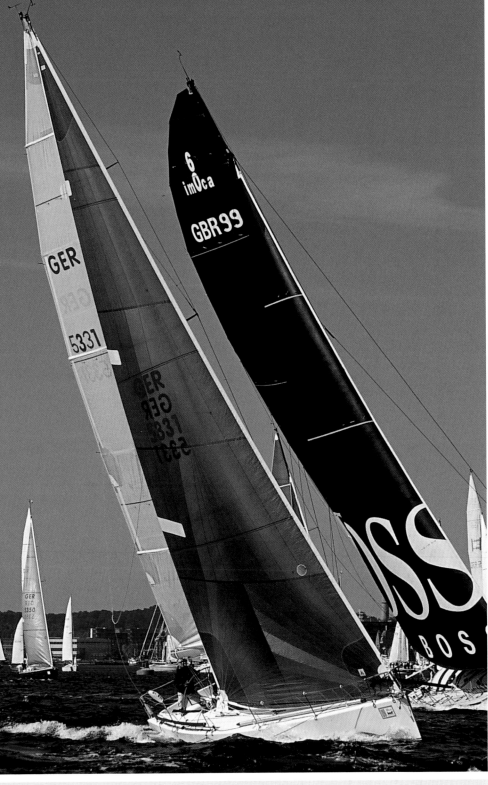

**Top right:**
Sailors having a break, with the famous loading bridges of the Howaldts-werke-Deutsche Werft GmbH (HDW) on the Kiel Fjord behind them.

**Centre right:**
At the windjammer parade the green sails of the Alexander von Humboldt simply cannot be over-looked. The ship became famous the world over in adverts for a well-known brewery.

**Right:**
A veritable forest of sailing masts: the Kieler Woche is when the best sailor sportsmen from all four corners of the globe come together.

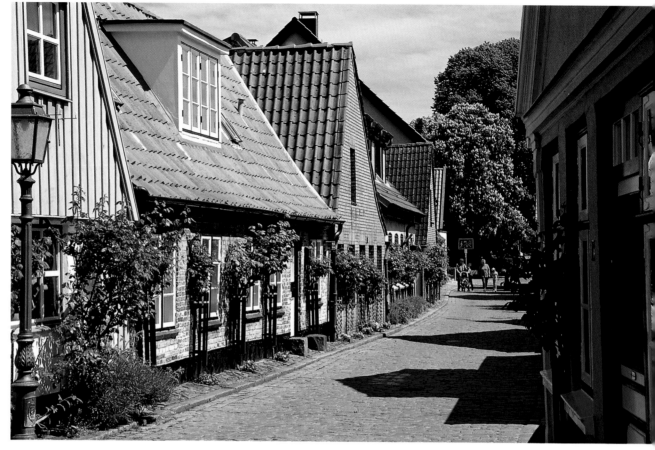

Holm is the fishing quarter on the edge of the old town of Schleswig. It began in c. 1000 when the settlement was still on an island in the River Schlei. Holm wasn't linked up to dry land until the 20th century.

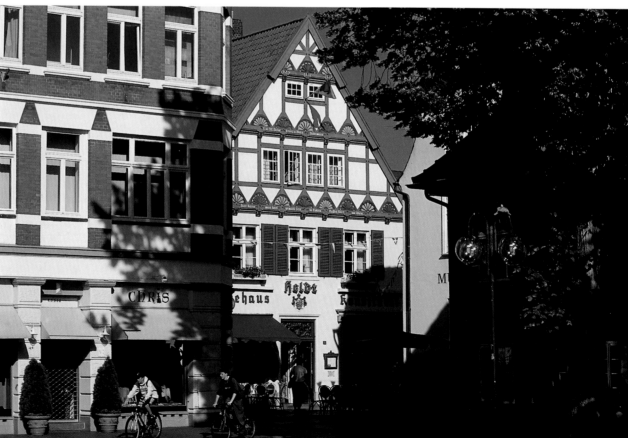

The Rathausmarkt in Eckernförde. The old town boasts a multitude of beautiful half-timbered houses. From here it's not far to the beach with four kilometres (13 miles) of golden sand. Eckernförde was made a recognised Baltic resort in 1831.

**Right page:**
The old seaside town of Borby (or Borreby in Danish) on Eckernförde Bay was made part of Eckernförde on April 1, 1934. The oldest building here is the church which was begun in 1185.

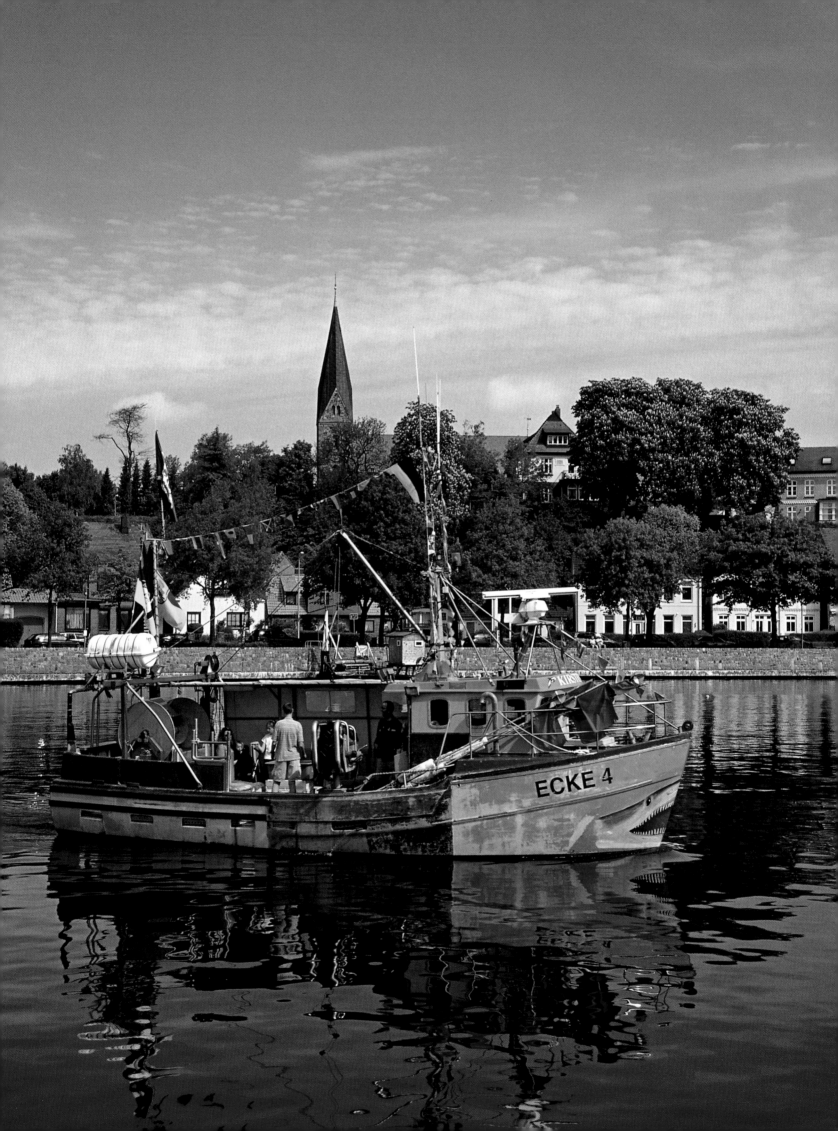

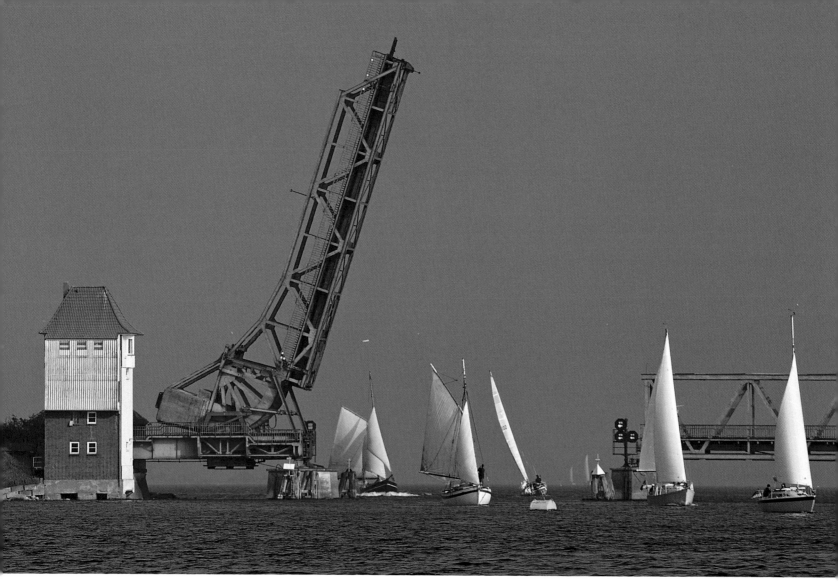

**Above:**
The Lindaunisbrücke from 1926, which was listed in 1997, crosses the Schlei at its narrowest point in Lindaunis, part of Boren in the district of Schleswig-Flensburg. The bridge is used by road and rail and opened once an hour to let ships through.

**Right:**
The "herring fence" in the River Schlei is a system of permanently anchored fishing nets which have been used to trap herring since the Middle Ages. It's one of the sights of Kappeln and the last of its kind in Europe. The system is reckoned to be over 500 years old.

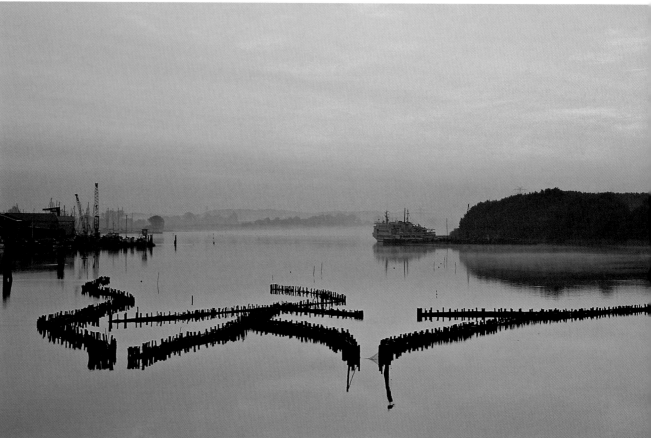

**Above:**
Dusk near Langballigau
on the Flensburg Fjord.
Langballigau was built as
a fishing port in the 1920s
and is now used primarily
by yachtsmen.

**Left:**
One of the nine
suspension ferries in the
world still in existence is
between Osterrönfeld and
Rendsburg. It crosses the
Kiel Canal suspended from
the viaduct at Rendsburg,
constructed in steel
between 1911 and 1913.

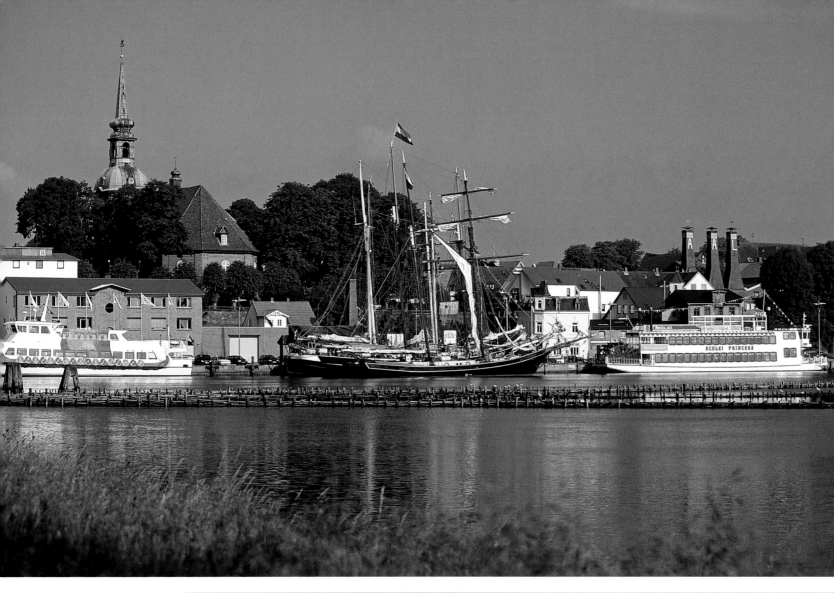

**Above:**
For centuries Kappeln on the Schlei was a fishing village. Besides the giant herring nets from the 15th century the late baroque church of St Nikolai is also worth visiting, as is the Schlei Museum with its maritime treasures.

**Right:**
On the banks of the Schlei south of Kappeln is Grödersby. The windmill from 1888 was recently restored and is now lived in.

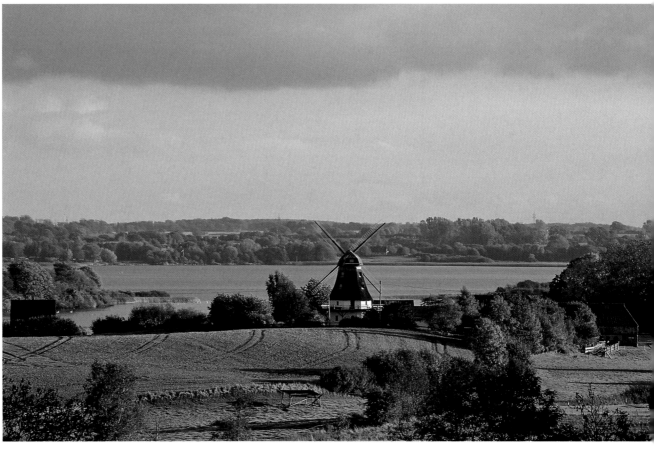

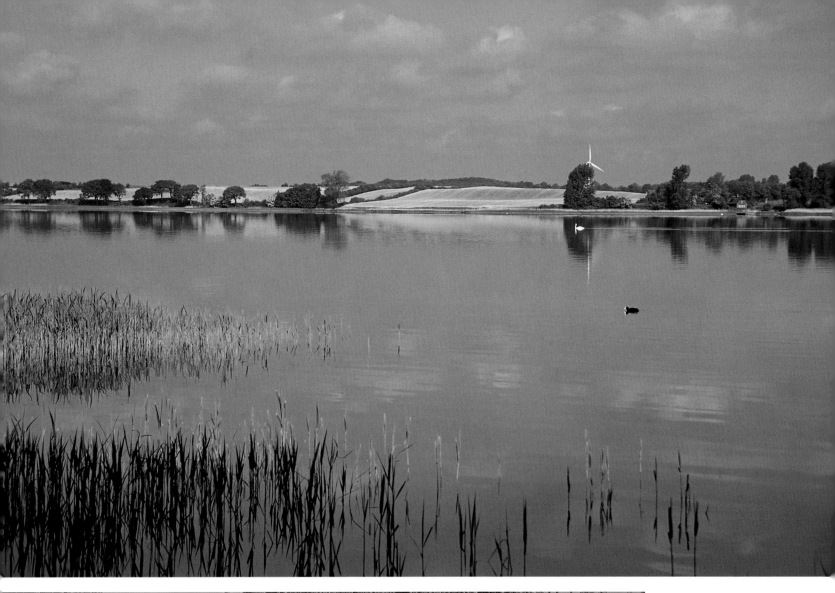

**Above:**
*On the Schlei. The river has an average width of 1.3 kilometres (about a mile) and a mean depth of three metres (10 feet). Its water is brackish, a mixture of fresh water and salty seawater.*

**Left:**
*Sieseby is a protected historical estate about twelve kilometres (seven miles) southwest of Kappeln on the River Schlei. Its charming thatched cottages are a joy to behold.*

*Right:*
*Gut Krieseby south of Sieseby, in the Schwansen countryside between the Schlei and Eckernförde Bay. Even today many of the palaces and manors in the area are owned by members of the nobility. Up until 1765 there was a famous faïence manufacturer's at Krieseby which was then moved to Eckernförde.*

*Below:*
*The Angeln area lies sprawled between the Flensburg Fjord and the Schlei. The hilly country-side with its patchwork fields, dense hedgerows and beech woods is like a naturally landscaped garden.*

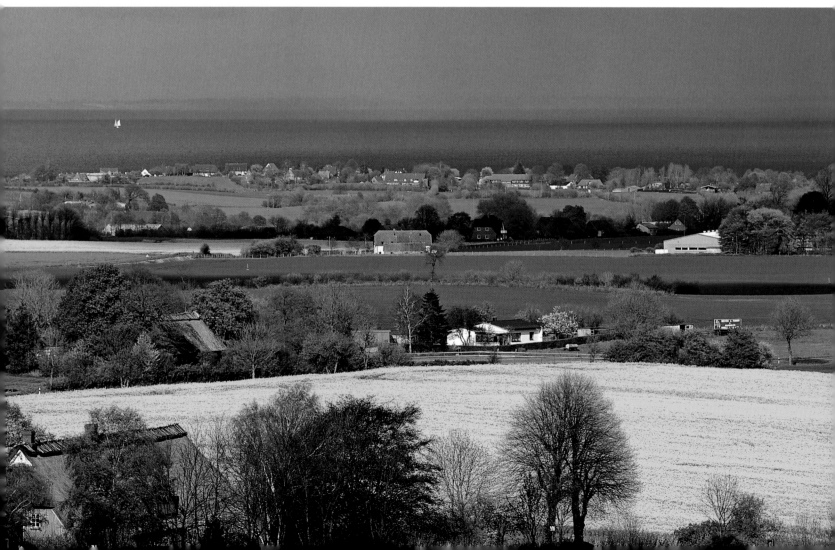

**Above:**
Countryside near Panker
north of Lütjenburg in
the Plön district. The
rape fields in flower are
a glorious sight enjoyed
by thousands of visitors
each year.

**Left:**
Near Schwedeneck on
the peninsula Dänischer
Wohld between Eckern-
förde Bay and Kiel Fjord.
This historic landscape
is also hilly, with fields
of corn and rape planted
behind the beaches and
steep cliffs.

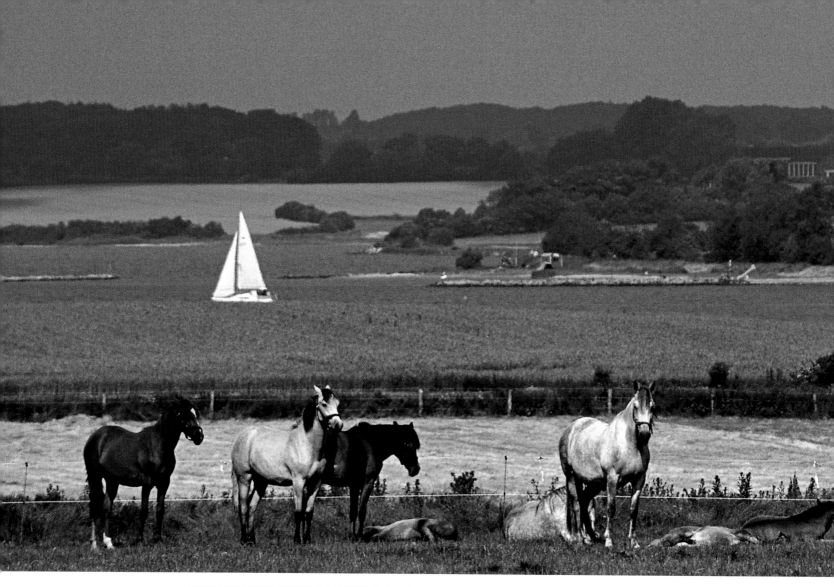

***Above:***
With just over 300 inhabitants and a surface area of a mere 0.45 square kilometres (0.17 square miles), Arnis is the smallest town in Germany in terms of both populace and area. It's situated on a peninsula in the River Schlei.

***Right:***
Ferries have serviced the short stretch of water between Arnis and the opposite bank of the Schlei since 1826. The ferry was motorised in the 1960s.

**Small photos, left:**
Every two years tens of
thousands of steam fans
make the journey to
Flensburg for the Dampf-
Rundum festival. The
harbour is packed with
things that puff – from
traditional ships to customs
cruisers, from steam
engines to steamrollers to
brass players!

**Page 132/1**
The Flensburg sky
is punctuated by
towers of the evangeli
Marienkirche and
Altes Gymnasium.
four hundred years
gateway to Scandina
belonged to Denma

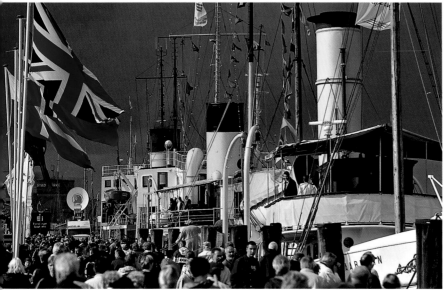

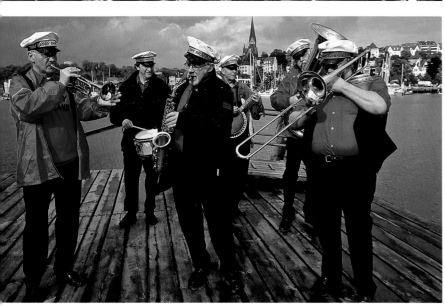

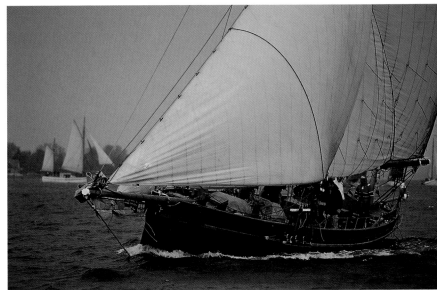

**Below and top right:**
*Every year at the end of ay over a hundred historic ships meet for the Rum Regatta on the Flensburg Fjord. The name of the regatta is reminiscent of the days when Flensburg was a big rum town.*

**Centre right:**
*Besides prizes for the regatta other awards are also handed out, such as for the best restored ship of the past year – or for stylish incongruity and flagrant errors in the overall appearance of the craft.*

**Bottom right:**
*In 1993 the basement of the shipping museum in Flensburg was turned into a museum of rum.*

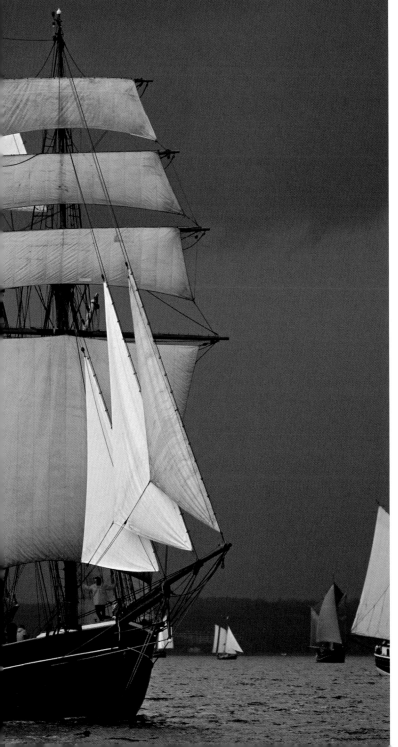

131

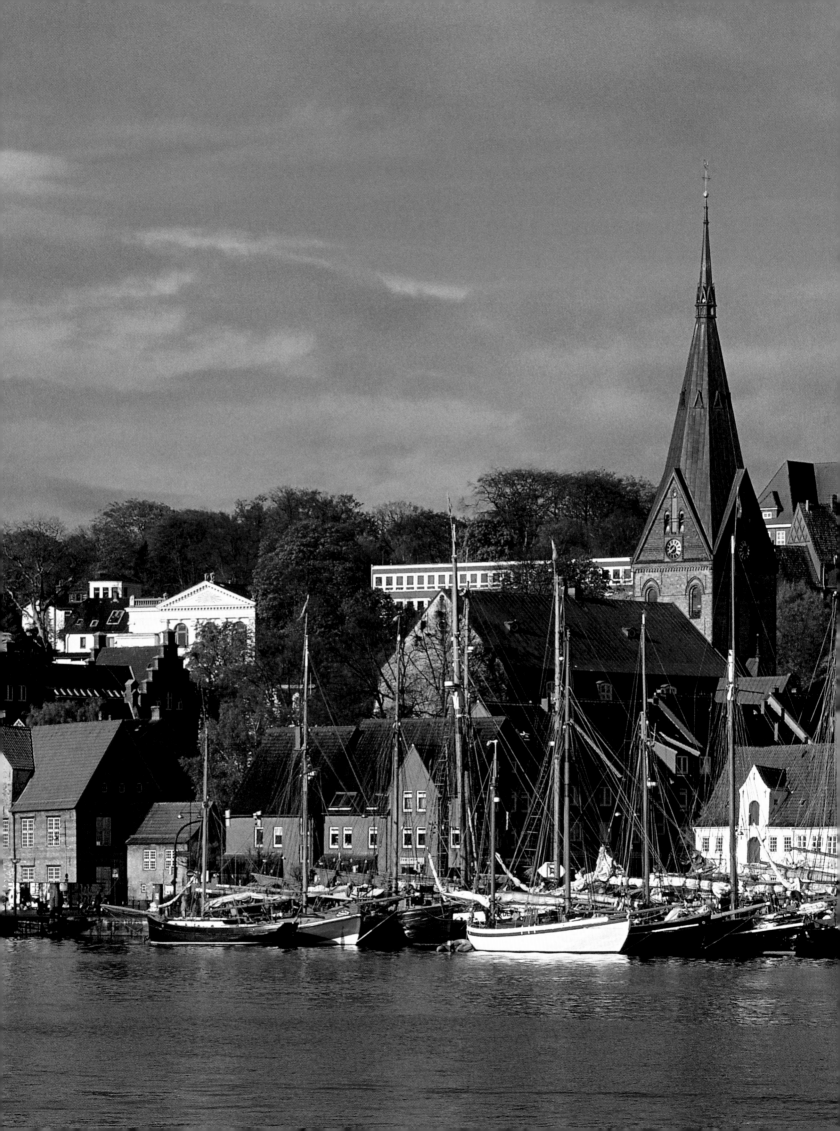

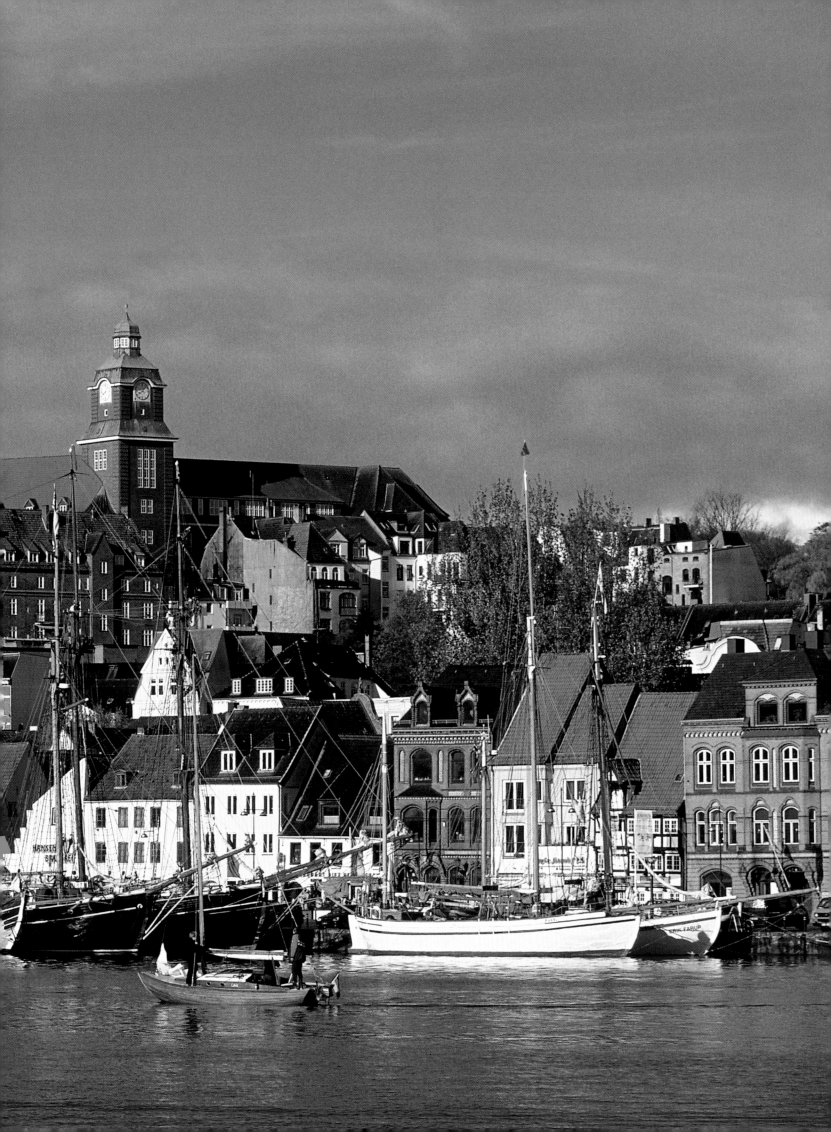

# INDEX

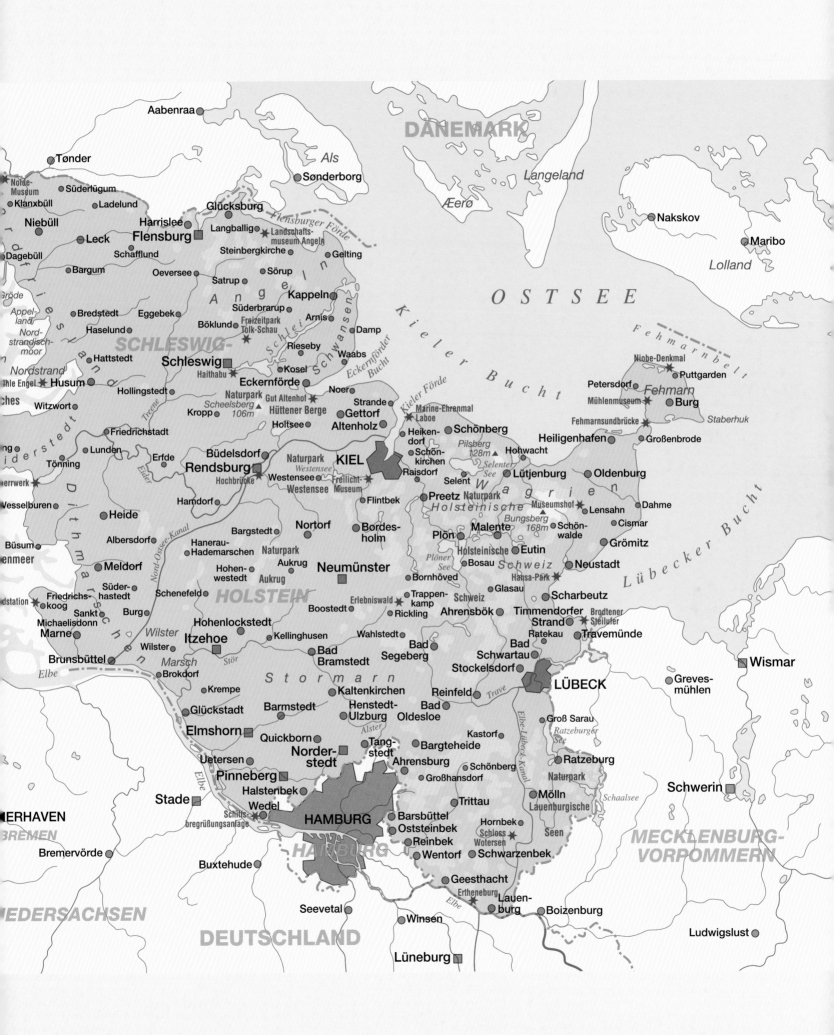

*Fishing cutter near Hörnum setting off in the early morning light in the hope of a good catch. With such fantastic lighting and a calm sea the day promises to be a fine one. Welcome to Schleswig-Holstein!*

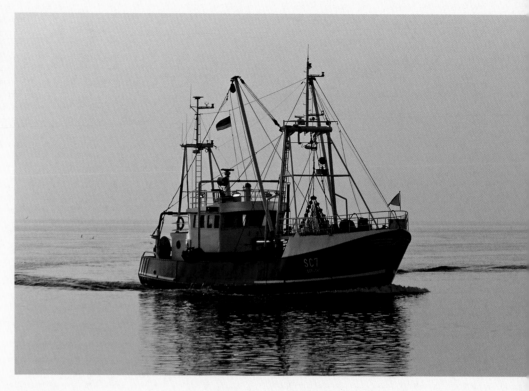

### Credits

**Design**
www.hoyerdesign.de

**Map**
Fischer Kartografie, Aichach

**Translation**
Ruth Chitty, Stromberg
www.rapid-com.de

All rights reserved

Printed in Germany
Repro: Artilitho, Lavis-Trento, Italy – www.artilitho.com
Printed/Bound: Offizin Andersen Nexö, Leipzig
© 2009 Verlagshaus Würzburg GmbH & Co. KG
© Photos: Karl-Heinz Raach and Johann Scheibner
© Text: Georg Schwikart

ISBN 978-3-8003-1925-1

### Photo credits

Karl-Heinz Raach
Back jacket, p. 6/7, p. 10/11, p. 12/13, p. 14/15, p. 18/19
p. 20/21, p. 24/25, p. 26-33 (12 ill.), p. 24/25 (3 ill.), p.
36-65 (48 ill.), p. 66 below, p. 67 above, p. 69-73 (11 ill.
p. 74 below, p. 74/75 centre, p. 76-85 (20 ill.), p. 86
above, p. 87 below, p. 88-95 (16 ill.), p. 99 (4 ill.), p.
100/101, p. 105 below, p. 113 below, p. 115 below.

Johann Scheibner
Front jacket, p. 5, p. 8/9, p. 16/17, p. 22/23, p. 34/35 (5
ill.), p. 66 above, p. 67 below, p. 86 below, p. 87 above,
p. 96/97 (4 ill.), p. 102/103, p. 104 (4 ill.), p. 105 above,
p. 106-112 (17 ill.), p. 113 above, p. 114 (2 ill.), p. 115
above, p. 116-133 (35 ill.), p. 136.

The publisher's archives
P. 75 right (6 ill.), p. 98 below right.

Archiv Spurzem
P. 98 below left.

Details of our programm can be found at
**www.verlagshaus.com**